IMAGES OF ENGLAND

WELWYN GARDEN CITY

IMAGES OF ENGLAND

WELWYN GARDEN CITY

ANGELA ESERIN

First published in 1995 by Tempus Publishing Limited

Reprinted 1999, 2004

Reprinted in 2011 by
The History Press
The Mill, Brimscombe Port,
Stroud, Gloucestershire, GL5 2QG
www.thehistorypress.co.uk

Reprinted 2013

British Library Cataloguing in Publication Data.
A catalogue record for this book is available from the British Library.

ISBN 978 0 7524 0133 1

Typesetting and origination by Tempus Publishing Limited.
Printed and bound in Great Britain by
Marston Book Services Limited, Didcot

Contents

Acknowledgements 6

Introduction 7

1. Before the Garden City 9

2. Early Days 25

3. The Town Develops 49

4. Industry 67

5. Community Spirit 85

6. Post War Expansion 113

Acknowledgements

All of the photographs in this book have been loaned or donated to Welwyn Garden City Library over the years and grateful thanks are due to everyone who has contributed to the collection. In writing this book my particular thanks go to all members of the Photo History Group for their many hours of invaluable assistance and to Ken Wright, Harry Stull and Eric Balley for their generous help and encouragement. My colleagues at Welwyn Garden City Library must also be mentioned for their patient forbearance, in particular Pat, Sharon and Mary of the Regional Office who cheerfully typed my appalling handwriting and were always so wonderfully supportive.

Picture Credits

Aerofilms p. 36, 50 and 61
Eric Balley p. 65 top
Commercial Motor Magazine p. 76 bottom
Herts Advertiser p. 111 top
ICI Plastics Division p. 83
Imperial War Museum, (Neg. no. H26041) p. 64
Harry Stull p. 106 top; p. 126 bottom; p. 127 bottom
Peter Way p. 124 bottom
Welwyn Times p. 97 bottom
Denis Williams p. 105

Ken Wright p. 82 bottom; p. 84 bottom; p. 103; p. 107 top and most of the photographs in Chapter 6 with thanks to the Commission for the New Towns for permission to reproduce them.

Apologies are offered to any copyright holders of photographs whom I have inadvertently failed to acknowledge.

Introduction

Welwyn Garden City is unusual in that it owes its existence to the ideas of one man, Ebenezer Howard. Appalled by the overcrowded slum conditions he saw in London, he put forward in 1898 his ideas for creating properly planned moderate sized towns surrounded by a green belt. There would be pleasant houses and gardens conveniently near to places of work, with good amenities and an abundance of open space. His ideas were the inspiration of the world-wide Garden Cities, later New Towns, Movement.

With a group of like minded individuals Howard formed a private company and in 1903 began to build his first garden city at Letchworth. Although a gradual success Howard was concerned that Letchworth was in danger of being seen merely as a one off experiment, so he determined to build a second garden city to disprove his critics. On train journeys to London he saw the ideal site, just north of Hatfield and then part of the Panshanger House estate, and he even took two of his friends for a walk around it in 1918. By a strange twist of fate, the very land that Howard admired was put up for auction by its owner Lord Desborough in May 1919. Howard had only a short time to raise at least £5,000 deposit from his friends and supporters as he himself was not a wealthy man and could only afford £50. His bid at the auction sale was successful and so he found himself in 1919 nearly 70 years of age, with a debt of £51,000 and facing the task of building a complete town on a site of largely agricultural land with no proper roads or amenities. Undaunted he and his followers founded the company Second Garden City Ltd., later Welwyn Garden City Ltd., and set about their enormous undertaking.

Houses were constructed, roads laid out, and people and industry attracted to join the new venture. At first the town resembled a huge building site with mud everywhere and wooden huts for schools and meeting places. There were

no street lights or proper pavements and people wore wellingtons and carried hurricane lamps if out after dark. Gradually things began to take on the shape we know today, following the plan of the town's architect Louis de Soissons. However, in the early years the company faced massive problems. The financial uncertainties of the 1920s and the depression of the early 1930s could hardly have been a worse time for such a risky enterprise. As Sir Theodore Chambers, the Company's Chairman, later wrote, "The real truth was that no one believed in the future of the town. Everyone, even our friends, was utterly sceptical." Despite such lack of confidence, particularly from City financiers, the Company never lost faith and pressed on with building the town. A sense of community quickly developed with the establishment of clubs and societies, churches and schools, and the town's population grew from 767 in 1921 to 8586 in 1931. By 1939 when the new Welwyn Department Store building now John Lewis, was opened, the future of the town was firmly assured.

In 1948, following the passing of the New Towns Act, Welwyn Garden City Ltd., was taken over by a government Development Corporation later the Commission for New Towns and the town moved from the private to the public domain. In succeeding years it grew considerably and now has a population of over 40,000.

Although the idealism of the early days has largely passed, the town remains a beautiful place in which to live and work and as possibly the finest example of a garden city it attracts architects and planners from all over the world.

The photographs in this book are intended to illustrate the story of Welwyn Garden City's development from green fields to the town of today, but it is hoped that they will also serve as a reminder of the debt owed to Ebenezer Howard and the early "pioneers" and of the vision and ideals that led to the town's foundation.

One

Before the Garden City

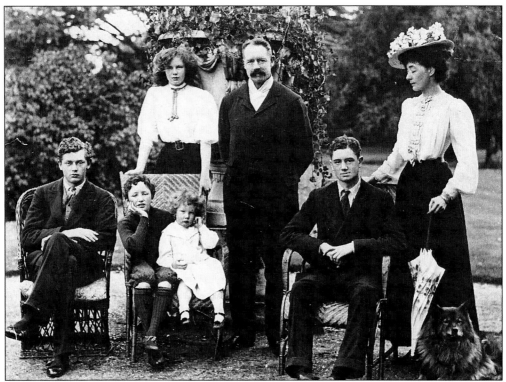

William Henry Grenfell, Baron Desborough, and his family at their home Taplow Court in Buckinghamshire in 1912. He inherited Panshanger House and estate on the death of Lady Cowper in 1913, but sold part of the estate at auction in 1919. It was this land, chiefly agricultural and sparsely populated, that Howard purchased to build Welwyn Garden City.

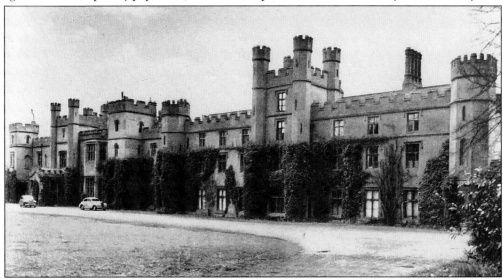

Panshanger House, which was built for the 5th Earl Cowper in 1806, was once one of Hertfordshire's great mansions with grounds laid out by Repton and a fine collection of china and paintings. After the death of Lady Desborough in 1952 the house, which had fallen into disrepair, was sold for demolition.

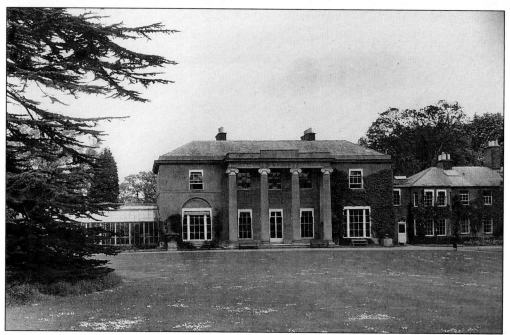

A view of Digswell House which was built by the 5th Earl Cowper in the early 1800's, replacing the original medieval manor house. It formed part of the portion of the Panshanger Estate bought by Howard in 1919, much to the dismay of its tenant Colonel Acland. The house is now private flats.

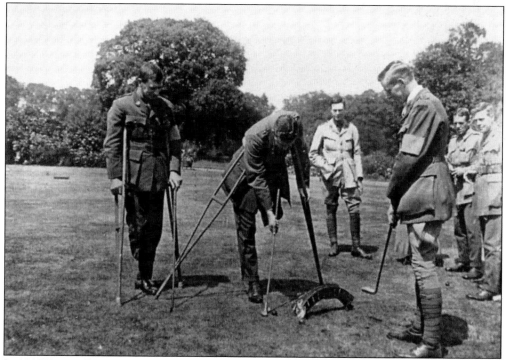

In 1917 Digswell House was used as an Australian Auxiliary Hospital and the photograph shows some of the wounded officers playing "Golfstacle" on the lawn.

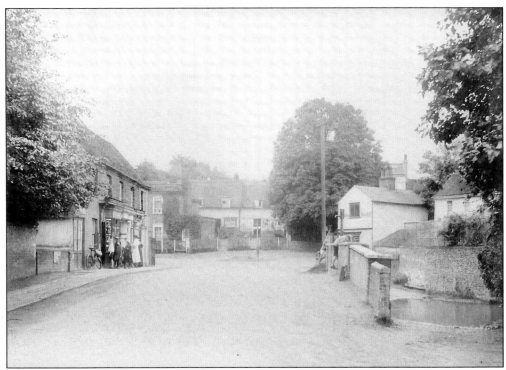

The High Street in Welwyn Village *c.* 1900. A settlement for centuries, situated on the Great North Road, Welwyn reached its heyday as a coaching centre in the eighteenth century. Welwyn Garden City was named after it to give a general indication of the position of the new town, but the two are completely separate and independent.

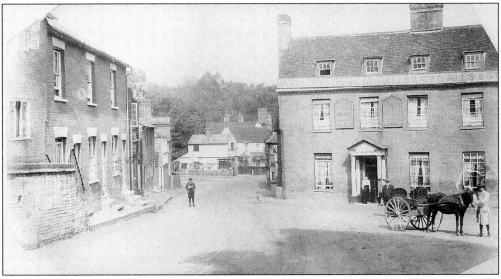

The Plain in Welwyn, originally the market place and also the site of the village pound. The pub shown, the White Hart, was one of the major coaching inns and at one time ran its own coaching service to London.

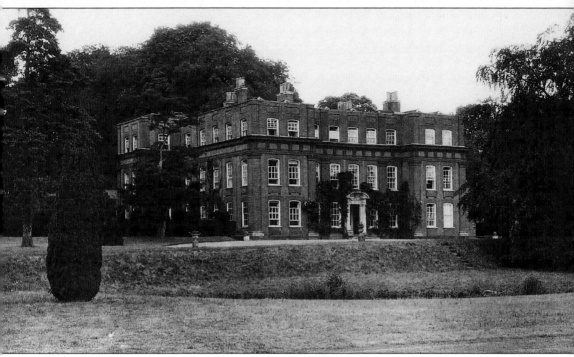

Lockleys, situated to the south east of Welwyn. Built by Edward Searle, a London merchant, in 1717 its most famous owner was the eccentric inventor George Dering. In 1936 the Lockleys estate was bought by the WGC Company but only a tiny portion of its land was ever built on, as the County Council refused planning permission much to the relief of Welwyn villagers. The house itself was purchased by its present owners, Sherrardswood School, in 1955.

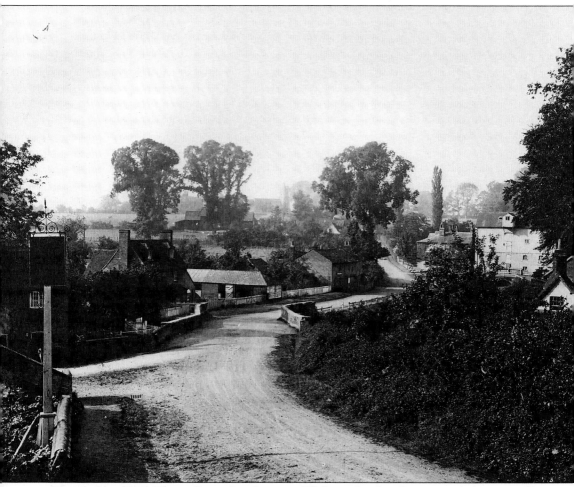

Lemsford in 1920. This village, the closest to Welwyn Garden City, provided a post office, shoemakers and a shop that "sold everything". The Sun Inn by the bridge kept cows and chickens, selling milk as well as beer. The working mill, run by the Sheriff family, was one of the first houses in the area to have electricity.

Opposite: The Mimram Valley to the north of the Garden City with Digswell viaduct built by Thomas Brassey in 1850.

Ayot Green *c.* 1920 with the village pump. The cottage in the centre of the photograph was the village post office and sweet shop where Fanny Gaylor and Dolly Fever sold such delights as gobstoppers and sherbert dabs. The village hall on the extreme right was later demolished for the widening of the A1.

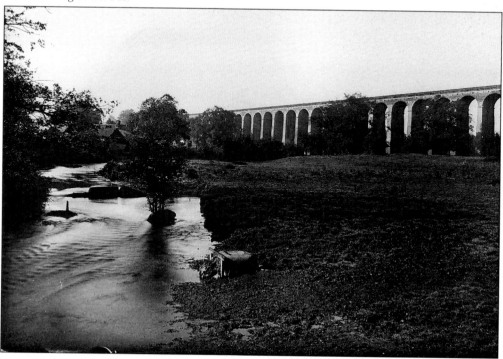

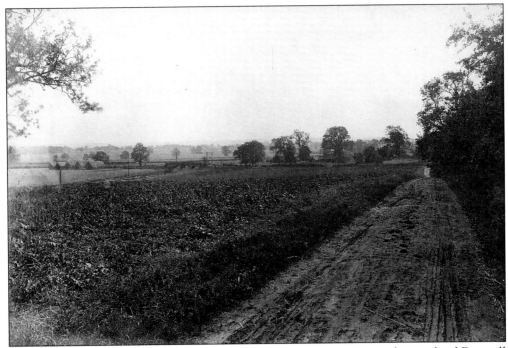

The lane from Digswell to Welwyn Garden City viewed from just to the north of Digswell Lodge Farm in 1919.

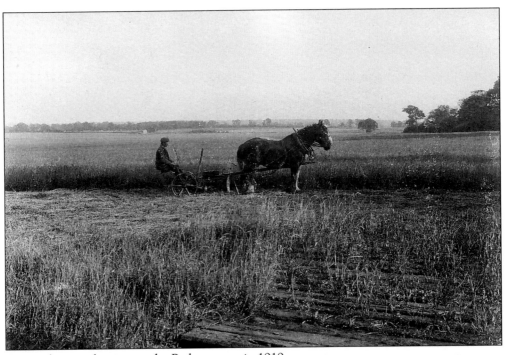

Cutting hay in what is now the Parkway area in 1919.

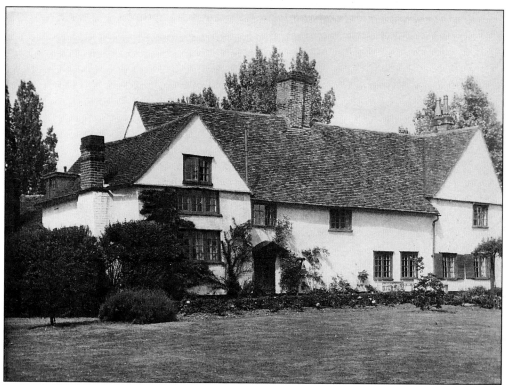

Ludwick Hall which dates back to the sixteenth century and was originally part of the medieval manor of Ludwick. At the end of the nineteenth century the estate was used as a stud farm. The Hall still exists hidden away off Beehive Lane at the top of the The Limes, its former drive.

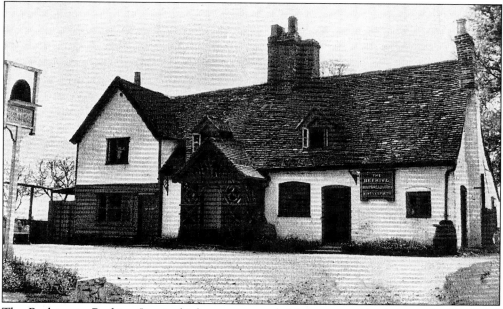

The Beehive in Beehive Lane which was surrounded by countryside close to the hamlet of Hatfield Hyde. Early Garden City residents used to walk to it down Woodhall Lane and Cole Green Lane which were then in the midst of fields.

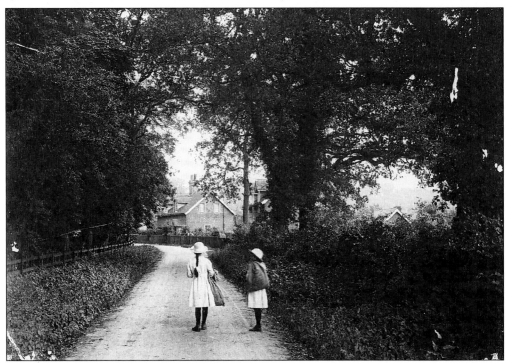

The cottages in Digswell Park Road which were originally part of the Digswell House estate.

Digswell Water Farmhouse *c.* 1920. The farm of around 330 acres was also purchased by Howard in the 1919 auction and formed the north eastern boundary of the Welwyn Garden City site.

Part of the Great North Road in the early 1920s. The proximity of such an important route, now the A1(M), to the site of Welwyn Garden City remains a major factor in the town's development.

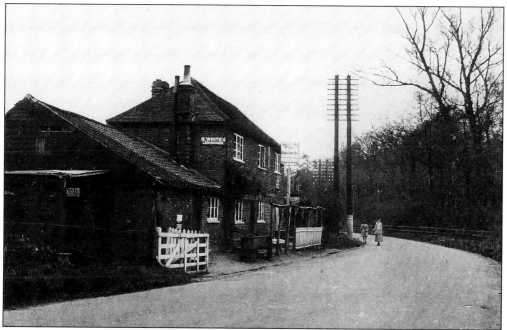

The Waggoners public house on the Great North Road c 1922. Although somewhat basic the pub became popular with early Garden City residents, particularly golfers, as the town's course was conveniently nearby.

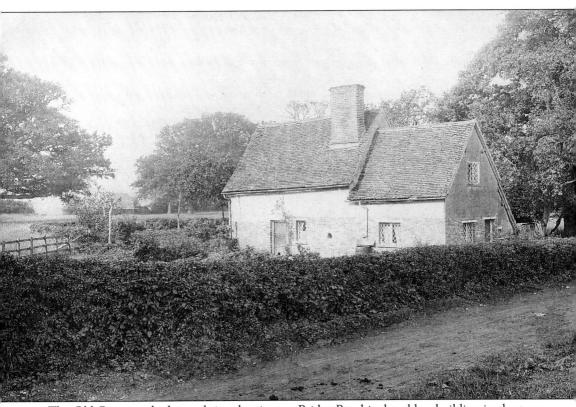

The Old Cottage which stands in what is now Bridge Road is the oldest building in the town dating back to 1604. It was part of the hamlet of Handside and was surrounded by fields as this 1920 photograph clearly shows. At that time it had an earth floor and cost one shilling and sixpence a week to rent.

Opposite: Digswell Lodge Farm House in 1922. The farm had been part of the Digswell manor estate since Norman times, the present house in what is now Digswell Rise dating from *c*. 1665. Bought by Howard in 1919 the house later became ICI's guesthouse. The farm continued until the 1950s when it was absorbed into Welwyn Garden City's post-war expansion.

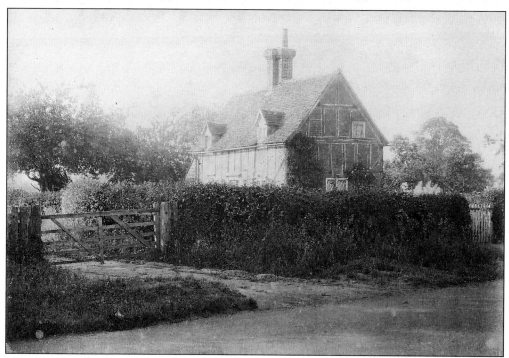

The old turnpike cottage situated on the Great North Road opposite Ayot Green. It was taken down piece by piece when the road was altered for the A1(M) in the 1960s, with the intention of re-erecting it in Hatfield, but planning permission for this was refused. It is now believed to be somewhere in Norfolk or Suffolk.

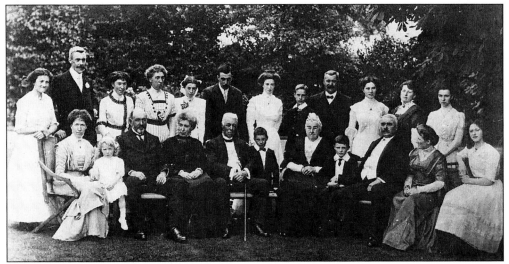

The Horn family of Handside, 10 July 1910, on W J and Sarah Horn's golden wedding. The family were tenants of Upper Handside, Lower Handside and Brickwall Farms, all of which were bought by Howard in 1919. Remarkably, the Horns welcomed the town and played a leading role in its development.

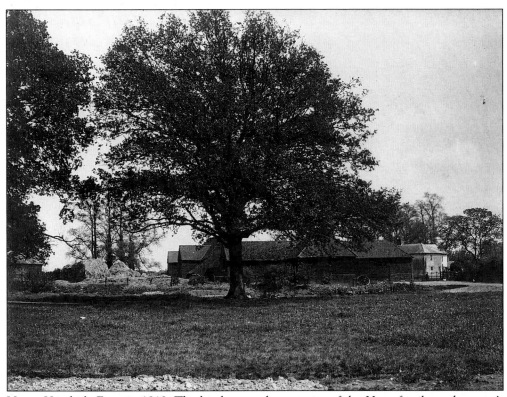

Upper Handside Farm in 1919. The kindness and generosity of the Horn family to the town's early residents is illustrated by the frequent tennis parties held here in the garden, followed by a huge farmhouse tea. The house was demolished in the late 1920's but the Old Drive which led to the farm still remains.

Handside Lane with the outbuildings of Upper Handside Farm *c.* 1919. The cart shed was later converted into the Backhouse Room.

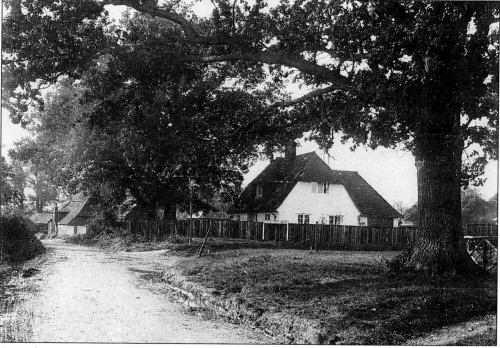

A similar view taken in the early 1920s with Applecroft Road laid out on the right. Many of the existing fine trees have been integrated into the new street design, something attempted wherever possible.

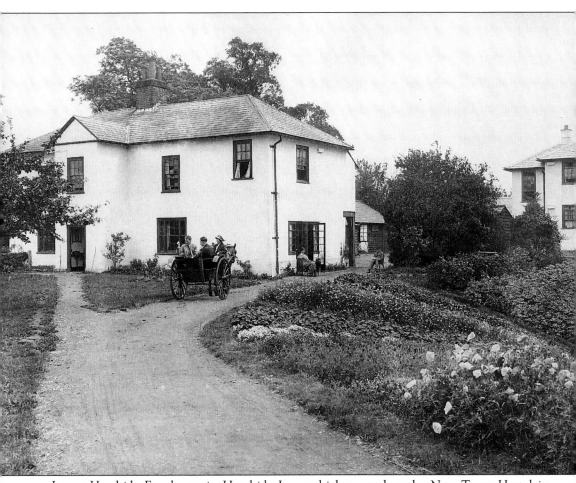

Lower Handside Farmhouse in Handside Lane which opened as the New Town Hostel in spring 1922 to provide accommodation for men and women working in the town. There were separate small bedrooms each with a gas fire, and a communal library and recreation room. Mrs R. H. Crowley was the warden. The building now forms part of the Barnside Court retirement development.

Two

Early Days

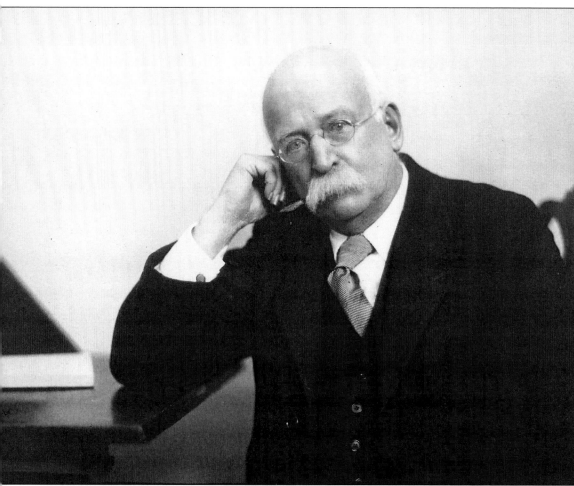

Ebenezer Howard. Howard was 69 when he bought the site for the town and set about the task of building his second Garden City. An unassuming man he made no great impression at first but he was surprisingly skilful at getting his ideas across and then leaving it to others to work out the details. When he died at his home in Guessens Road on 1 May 1928, the success of Welwyn Garden City was far from assured, yet it is a tribute to his abilities that the team he had assembled continued his work so successfully.

Frederic Osborn who became an enthusiast for Howard's ideas whilst working for him in Letchworth as a young man. As Estate Manager for Welwyn Garden City he was responsible from the outset for every aspect of the town's development until leaving the Company in 1936. Thereafter he devoted his remarkable energy and ability to the cause of Garden Cities and New Towns worldwide.

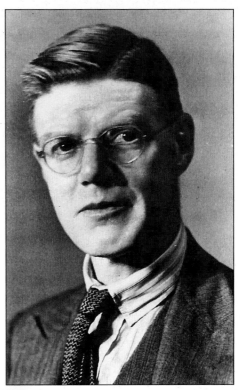

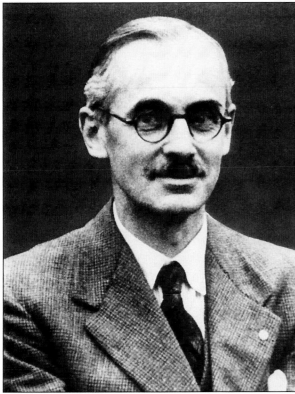

Captain W E James who was appointed as Engineer in January 1920. His first task was to supervise a detailed survey of the entire estate before building work began. For the next 25 years he was responsible for the roads, water and drainage so vital to the town's growth. Well-liked and respected, he also played a leading role in the town's social life.

27

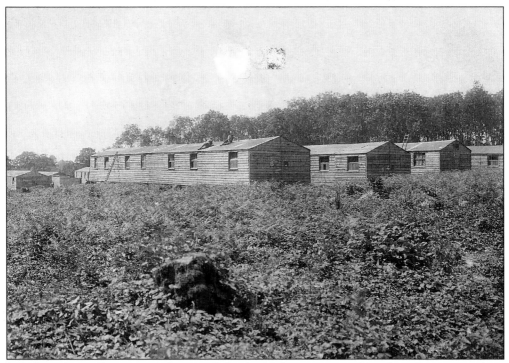

In order to house the many workers needed to build the town a number of wooden ex-army huts were erected on what is now the Campus. They provided basic accommodation until sufficient houses had been completed.

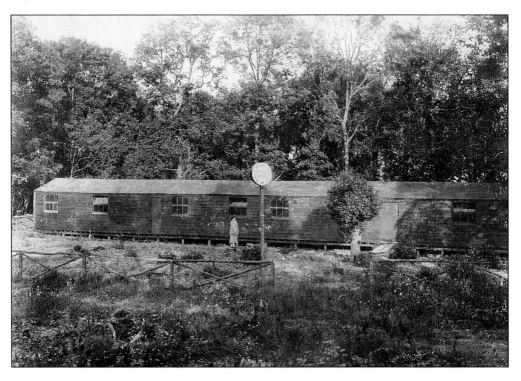

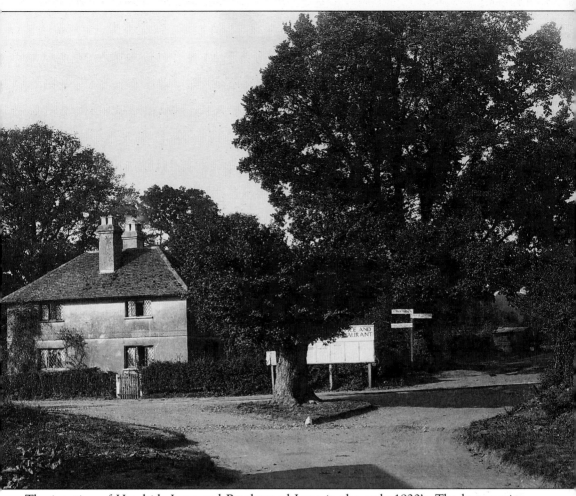

The junction of Handside Lane and Brockswood Lane in the early 1920's. The large notice board directs people to the Estate Office on the Campus and the Cherry Tree Restaurant. The cottages are still there today as is the enormous oak tree.

Opposite: The first Welwyn Garden City Estate Office, 1920. This hut was the office for the Welwyn Garden City Company and the centre of operations during the earliest years for building the town. The hut had no proper heating and the first job on winter mornings was to thaw the link which had frozen overnight.

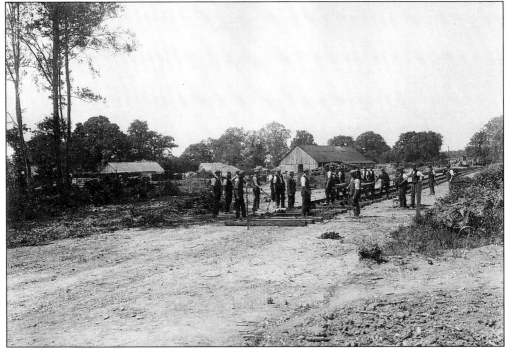

The construction of the Handside railway siding in 1920, to bring heavy building materials from the Luton Branch line to the goods yard. This lay roughly where Woodside House now stands in Bridge Road and was linked to the building site by a light railway.

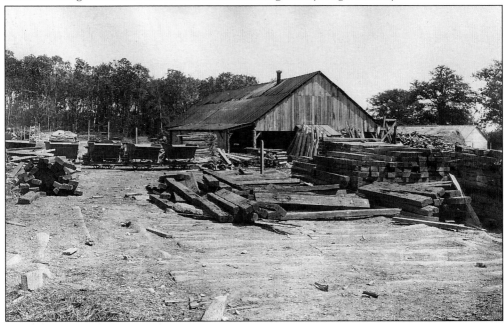

The sawmill and timber yard also in the previous photograph, which were originally used by German prisoners felling trees in Sherrardswood during the First World War. They later became the works and yard of Welwyn Builders. The light railway trucks transported building materials until proper roads were made.

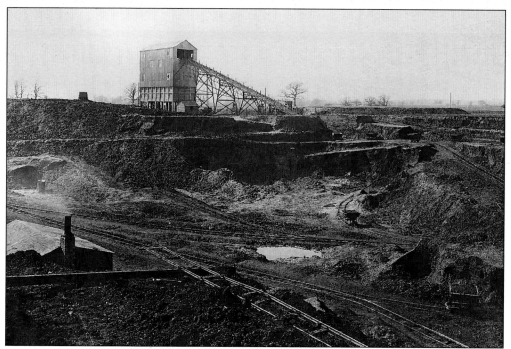

The gravel pit at Twentieth Mile *c*. 1927. Loaded wagons were hauled up to the top of the separating plant by an electrically driven winch. The gravel was crushed and washed and the residual clay used in the nearby brickworks. The pit was later used as a waste dump and is now the Burrowfields industrial site.

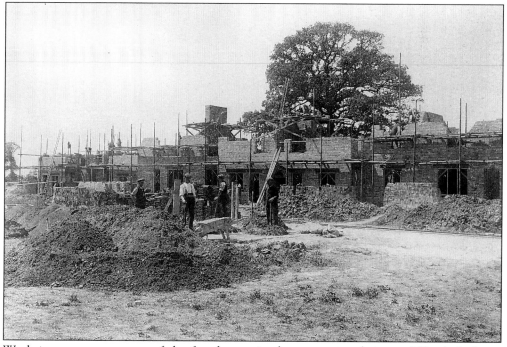

Work in progress on some of the first houses in the town near the top of Handside Lane. Designed by the Letchworth architect C M Crickmer they were completed at the end of 1920.

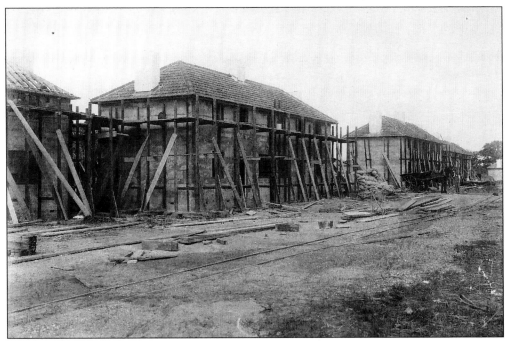

Early building in Brockswood Lane in 1921 with the track of the light railway clearly visible.

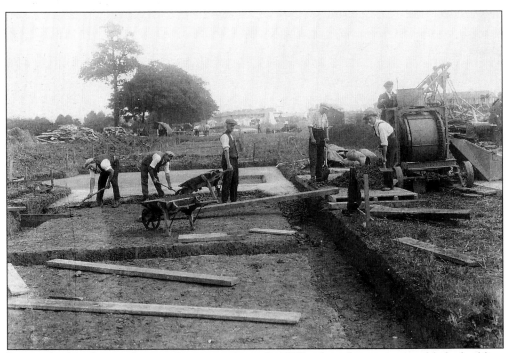

Laying the foundations for more houses in the early 1920s when the town resembled a building site. According to a local resident any trip out entailed "tramping across fields through mud in gum boots dodging the trenches and all the building paraphernalia".

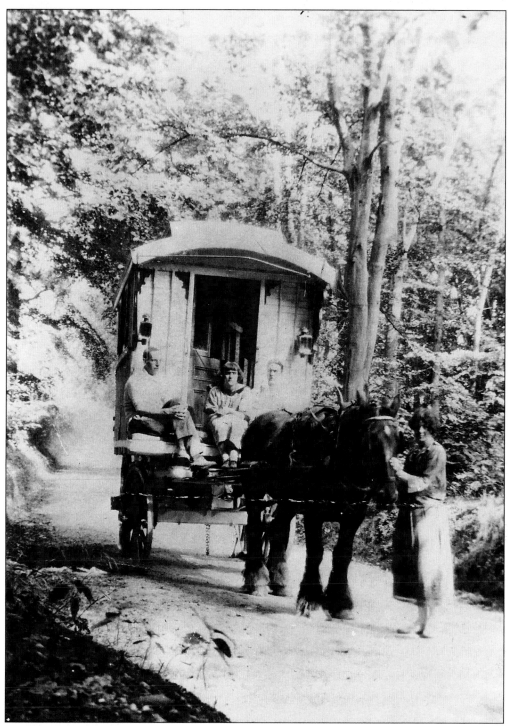

The Jennings family who claimed to be the town's first residents, on their way to Welwyn Garden City from Esher along the A1 in September 1920. Their horse was hired from a coal merchant and was returned to Esher by train from Ayot Green Station. For several months they lived in the caravan at Brickwall Farm until a house in Handside Lane became available.

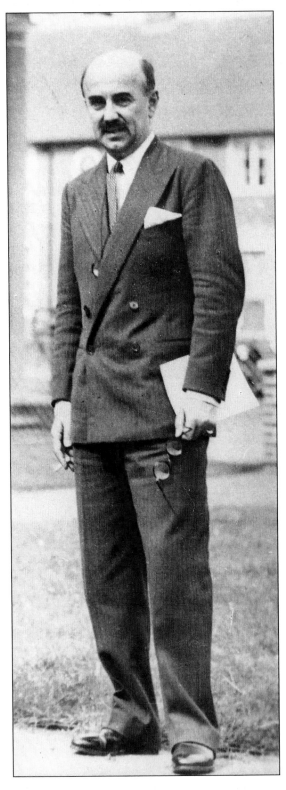

Louis de Soissons the town's architect
and planner who was appointed in
April 1920. Born in Canada he had
studied in Paris and Rome. He chose
the neo georgian style of architecture
for the scheme with red brick from clay
dug locally as the building material.
Although other architects worked
on housing schemes and buildings
all designs had to be approved by de
Soissons personally, thus ensuring a
unique conformity and standard of
excellence.

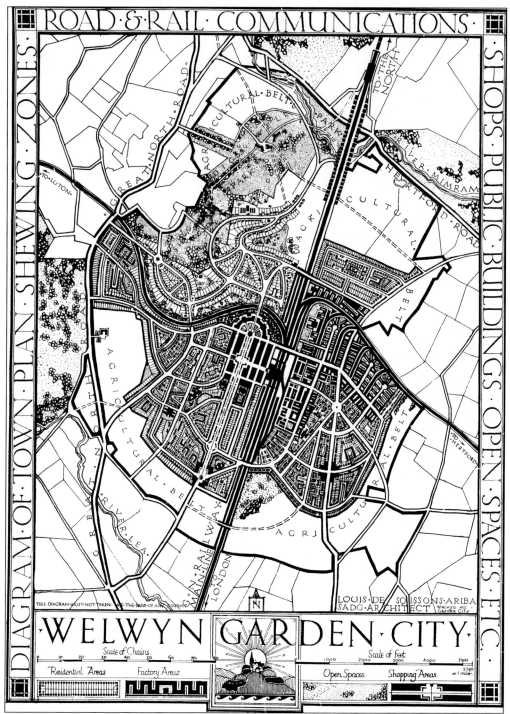

The town plan produced by de Soissons in June 1920. The boundary of the Great North Road in the west and the existing railway lines dictated the shape of his design. Although some changes were made, the major road layout and most of the central shopping area were built exactly as shown.

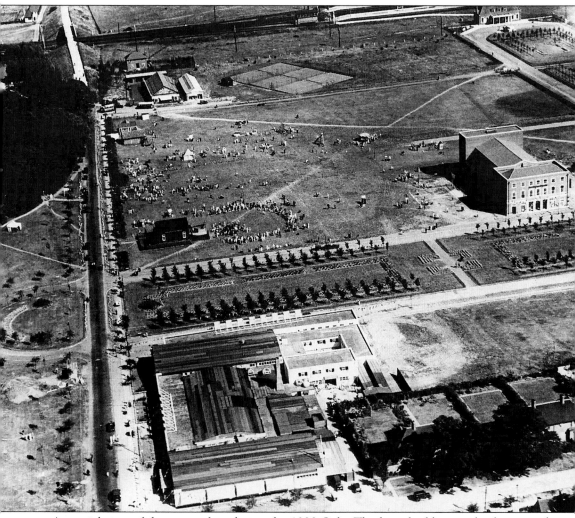

An aerial view of the town taken during the 1928 Gala. The large building in the foreground is Welwyn Stores with the Embassy theatre in Parkway and the station in Howardsgate clearly visible. The buildings nearest the tennis courts are Jenner Parsons garage and Munt's cycle shop. The smaller huts house Barclays Bank, the Council Offices and the Midland Bank.

An early view of Parkway looking north towards Digswell Bridge. The first Welwyn Stores and Cafe are on the left, Midland Bank's hut on the right. Despite the lack of buildings the landscaping of Parkway and the Campus are well advanced.

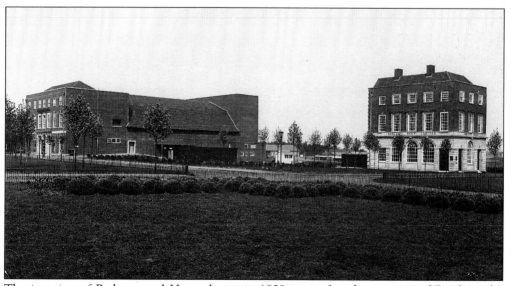

The junction of Parkway and Howardsgate in 1929 soon after the opening of Barclays, the town's first purpose built bank. The photograph clearly shows the bicycle shed at the side of the Welwyn Theatre – essential in a new town lacking in public transport.

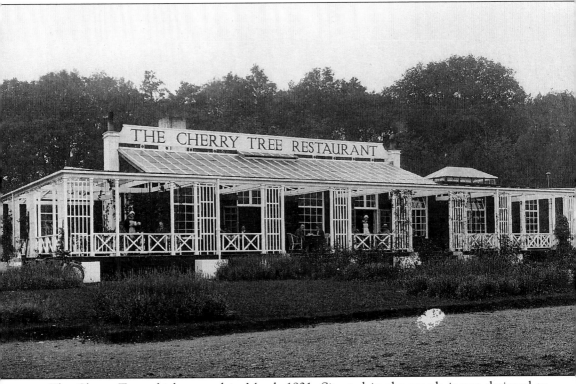

The Cherry Tree which opened in March 1921. Situated in the woods it was designed to resemble a continental cafe rather than ordinary licensed premises. It was modestly advertised as "The Finest Restaurant in Hertfordshire".

Opposite: The billiard room at the Cherry Tree probably *c*. 1922. More than just a restaurant, the Cherry Tree provided a social centre for the town with dances, concerts and society meetings held regularly. Two bowling greens were added in 1925 and a larger adjoining public hall, Bridge Hall, opened in 1928.

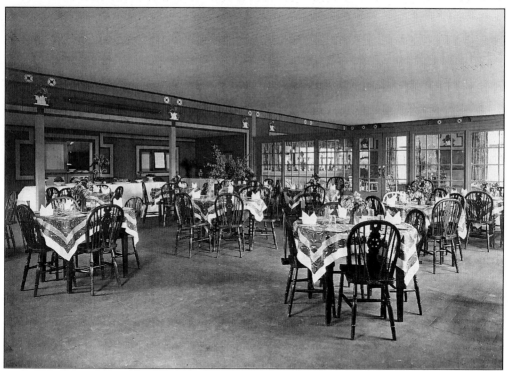

The Cherry Tree's dining room. Situated within walking distance of the station, it became a popular resting place for day trippers from London visiting the new Garden City.

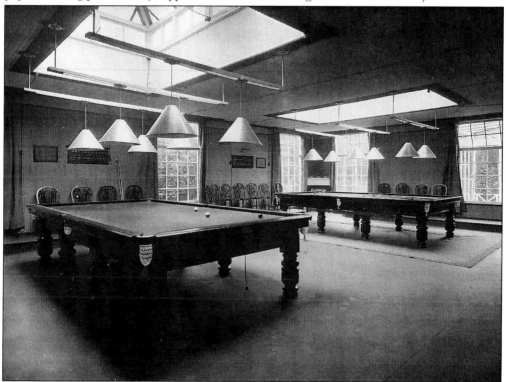

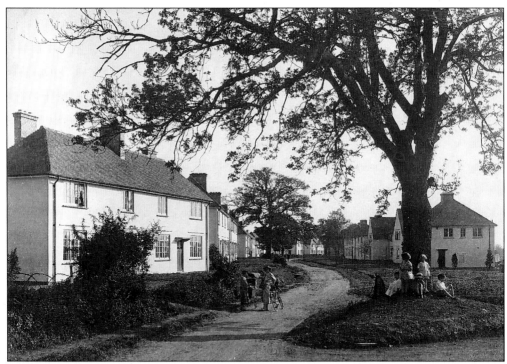

Handside Lane in the early 1920s soon after the first houses had been completed. Trees and original hedges were kept wherever possible and the curve of the lane was scarcely altered.

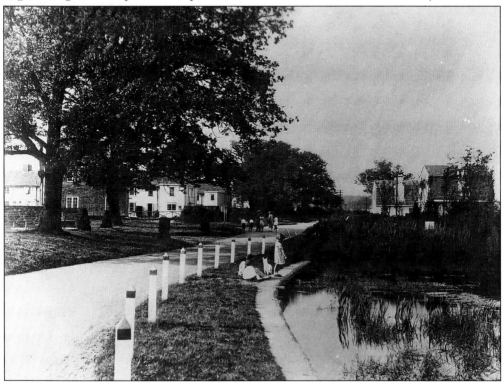

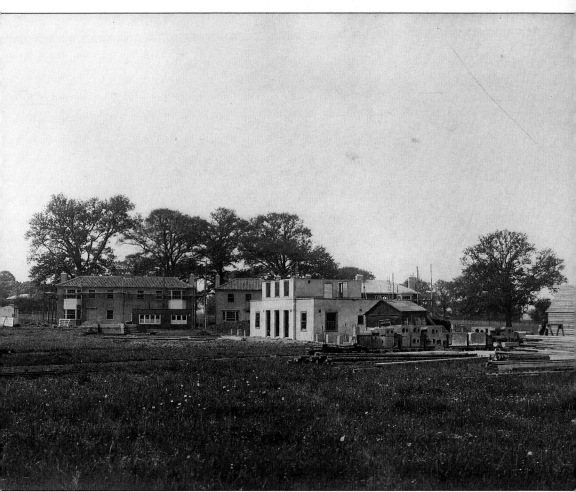

Work on the *Daily Mail*'s Ideal Village in Meadow Green. Opened by Earl Haig on 2 March 1922, it was designed to be a permanent showcase for new methods of construction. Forty-one cottages were built of either concrete, stone, brick or timber using a variety of building techniques and fitted with the most up-to-date appliances.

Opposite: The pond in Handside Lane opposite Meadow Green. Originally the pond for Lower Handside Farm, it provided many hours of amusement for younger residents fishing for tadpoles and crested newts. In July 1928 it was filled in as the water had become stagnant.

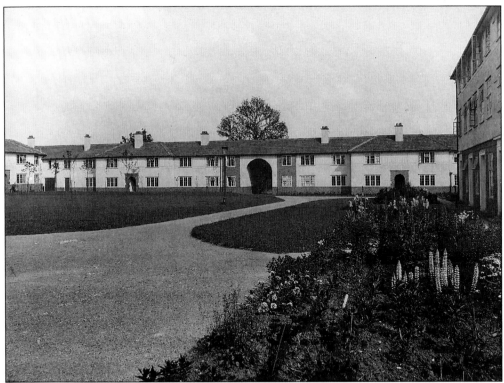

Guessens Court off Guessens Road, a co-operative housing scheme built for the New Town Trust in 1924. The service flats were grouped around a quadrangle with the taller restaurant block on one side. Kitchens were tiny as tenants were required to eat in the dining room each week. The flats are now retirement homes.

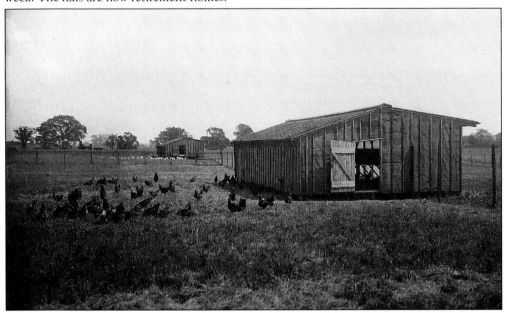

The poultry farm, started by the New Town Agricultural Guild in 1922, which was situated at the bottom of Handside Lane, is now the site of Marsden Green.

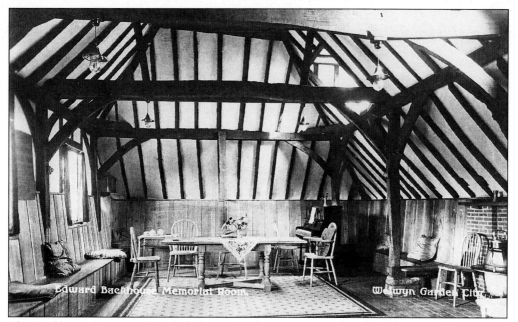

The Backhouse Room in Handside Lane which was converted in 1923 from an old cart shed belonging to Upper Handside Farm, to provide an educational centre for workers of the New Town Agricultural Guild. The name is in memory of the Guild's chairman Edward Backhouse who was killed in a climbing accident in 1922. The room is still in use today.

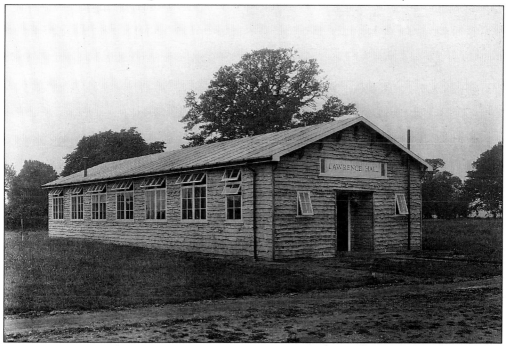

Named after Miss A J Lawrence of Letchworth who donated £800, this hall in Applecroft Road opened in July 1922. It had many uses as a school, church, boys' club, meeting place and clinic. It was home to the Welwyn Thalians opera group for 43 years until its demolition in 2005. Lawrence Court now stands on the site.

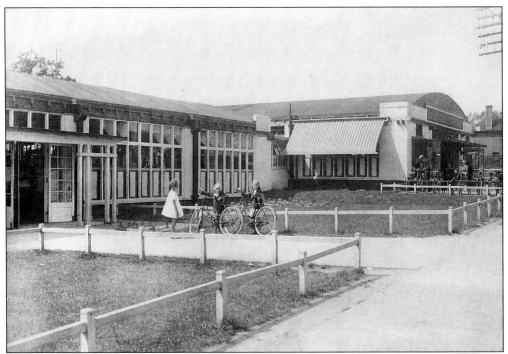

The original Welwyn Stores which opened on 14 October 1921 near the corner of Parkway and Bridge Road where Roseanne House now stands. Existing department stores such as Selfridges were reluctant to risk opening in the town so the Company set up a subsidiary "Welwyn Stores Limited", to provide shopping facilities themselves.

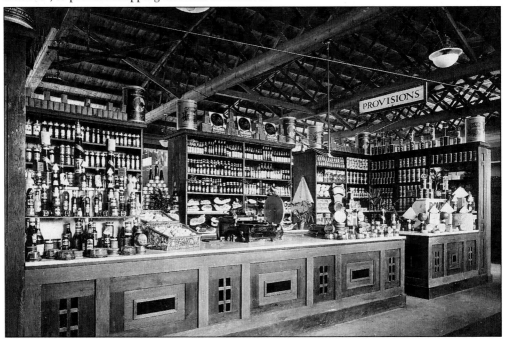

Part of Welwyn Store's provisions department and food hall in the early 1920s. The aroma of roast coffee emanating from here filled the entire building.

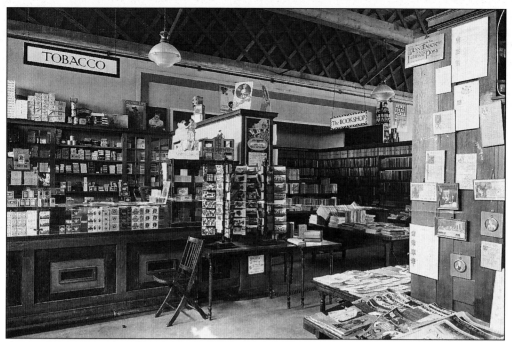

An interior view of Welwyn Stores. With over twenty-one departments the Store was the original one stop shop and meeting place for most of the town's residents. There was even a children's creche.

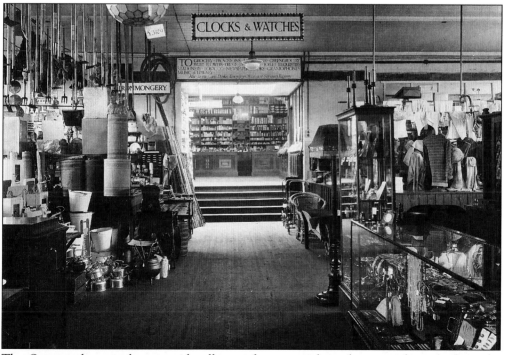

The Store endeavoured to provide all everyday essential goods as can be seen from the photographs and was a great boon to early residents who previously had to travel to nearby towns and villages for shopping.

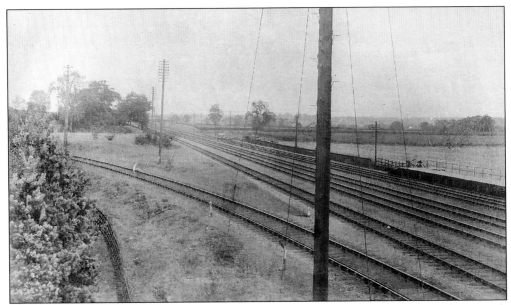

The railway junction at Welwyn Garden City in 1919 showing the main line looking north with the Luton branch line curving away to the left and the Hertford line going off to the right in the distance.

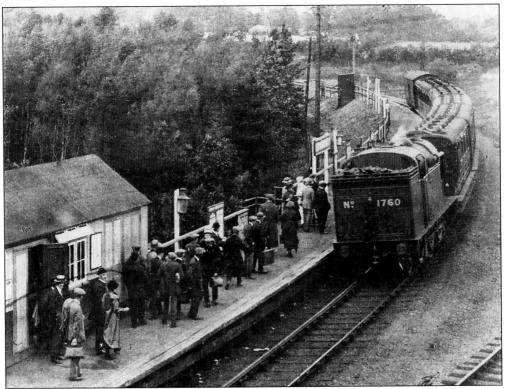

The first railway station on the Luton branch line which opened in October 1920. Passengers still had to change at Hatfield for the main line to London and the north, adding considerably to journey times.

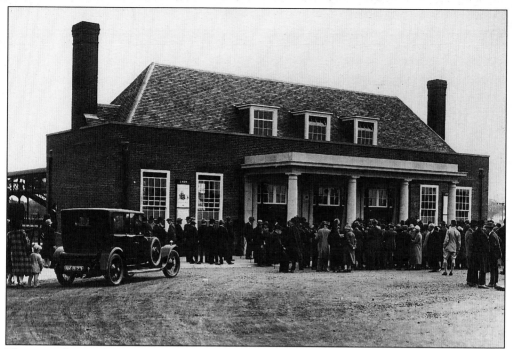

The main line railway station at the bottom of Howardsgate which was opened in 1926. It provided a direct line to London and was vital in putting the town on the map.

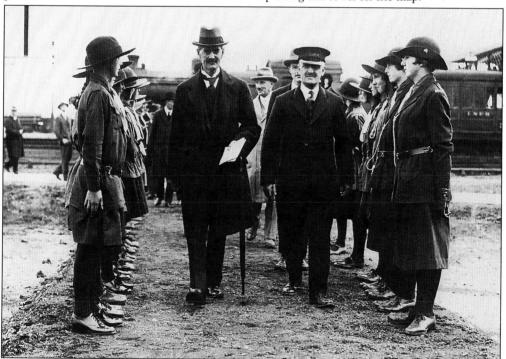

The Right Honourable Neville Chamberlain MP, a keen supporter of the Garden Cities movement, arriving to perform the station opening ceremony on 5 October 1926. The station master is Mr F J House, with F J Osborn and Sir Theodore Chambers in the background.

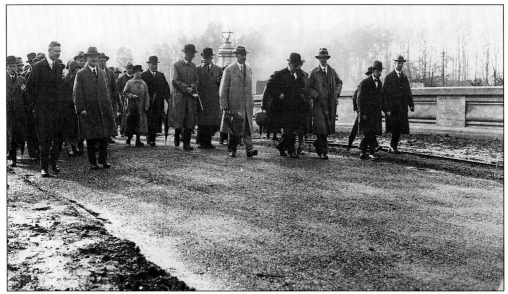

The opening of Digswell Bridge over the railway in October 1925. This provided a direct route north to Digswell which eliminated the need for the level crossing at the bottom of Blakemere Road.

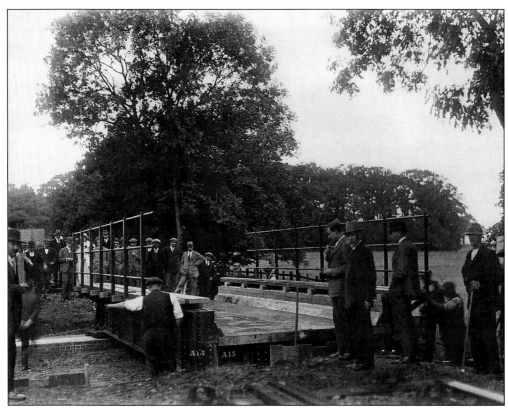

Constructing the railway bridge to take the Hertford line over what was to be Tewin Road in 1925. This was an important step in the development of the industrial area.

Three

The Town Develops

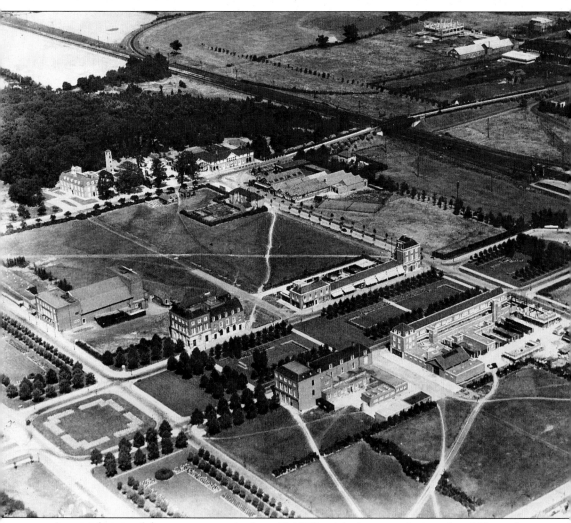

An aerial view of the town centre in the mid 1930s with the recently completed Howardsgate shops in the foreground. The well worn short cuts taken by local residents across the grass are clearly visible.

A publicity poster from the 1930s. These were displayed on Kings Cross station and elsewhere to advertise the town and encourage prospective residents.

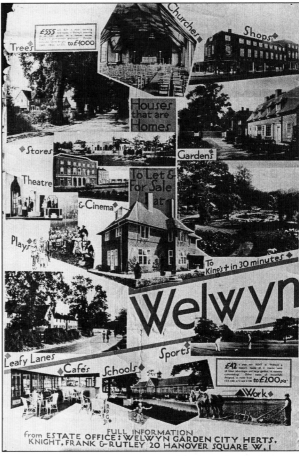

The Co-op in Howardsgate which opened in July 1936. There had been persistent criticism over the lack of shops in the town and over the Welwyn Stores' monopoly, so that the 1930s saw the building of the shopping centre in Howardsgate. However it took several years and much lobbying before the Company gave permission for a Co-op store.

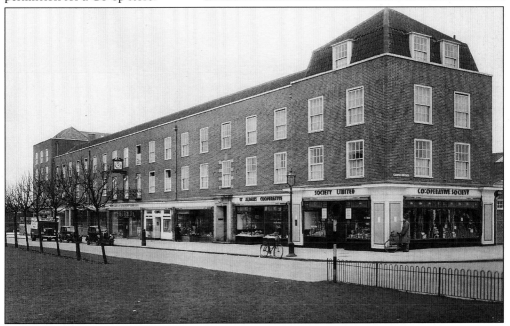

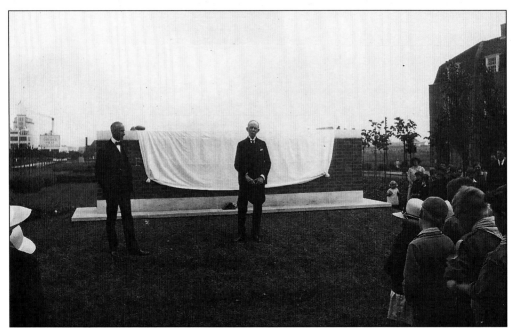

The unveiling of the Howard Memorial by the Earl of Lytton on 22 June 1930. Money had been raised through an appeal by an international committee to erect monuments in London, Letchworth and Welwyn Garden City.

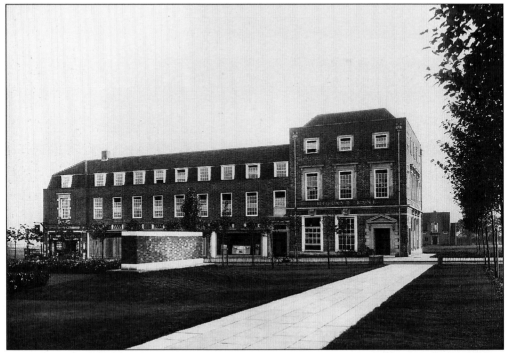

The Memorial in Howardsgate opposite the Midland Bank. From the outset it met with criticism being described as "a crude piece of brickwork" and "an unwanted lump". There were calls for a sundial or flowerbed instead. It was eventually removed and the new horizontal memorial at the top of Howardsgate unveiled in July 1964.

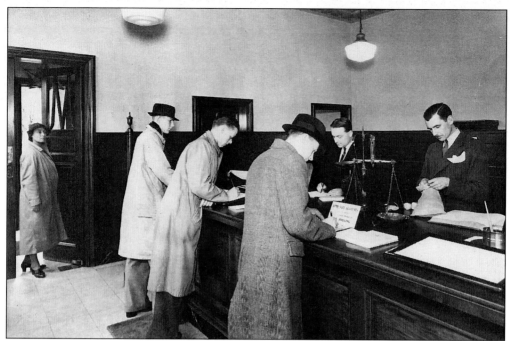

The interior of the Midland Bank in the 1930s. The cashier on the right is Mr Wadham. Barclays, the Midland and Lloyds Banks all took up permanent premises in Howardsgate around this time demonstrating a faith in the permanence of the new Garden City.

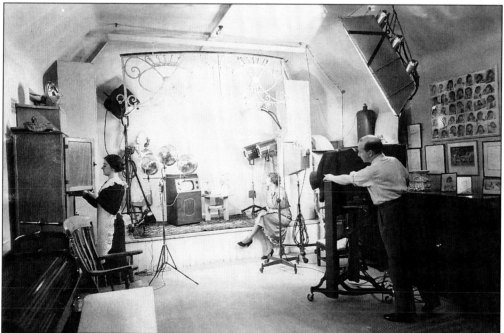

Studio Lisa at 14 Parkway. Lisa and James Sheridan arrived in 1936 and their photographs of the town taken during the 1930s and 1940s form an invaluable archive. Much of their commercial work involved child portraits and many a Welwyn Garden City baby was used to advertise various products, one appearing on packets of Farley's rusks for nearly 20 years.

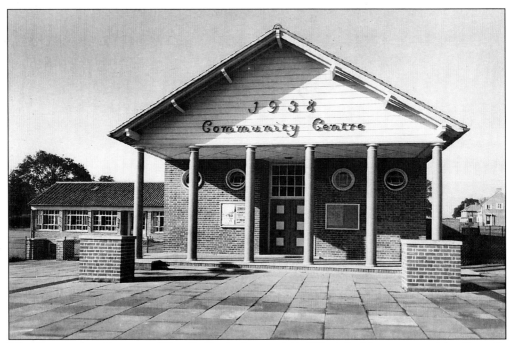

The Community Centre at Woodhall which cost £10,287 to build was opened by Prunella Stack, founder of the Women's League of Health and Beauty, on 9 July 1938. Dances were held there regularly, although jitterbugging and jiving were not allowed as they took up too much room on the crowded dance floor.

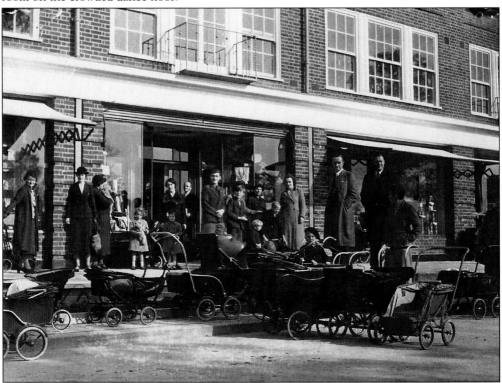

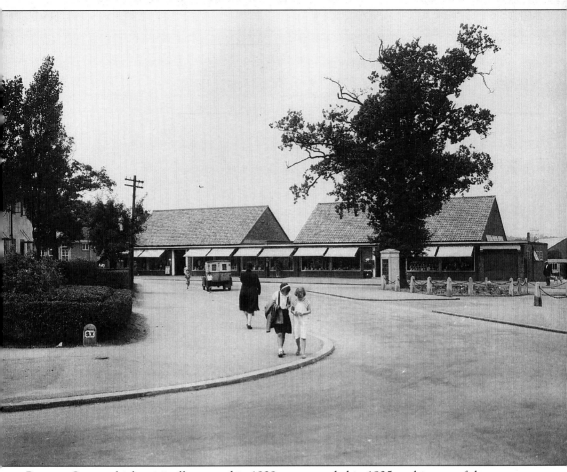

Peartree Stores which originally opened in 1929 was extended in 1935 as this area of the town developed. The easing of the depression and the growing number of industries attracted people from all over the country and by the end of 1934 all available houses in the Peartree area were let for the first time.

Opposite: Woodhall Stores on opening day 21 October 1938. With the newly opened Community Centre close by it was designed to help make this part of the town a real social centre for the east side and even boasted a snack bar. The collection of prams in the photograph illustrates the number of young families living in the town.

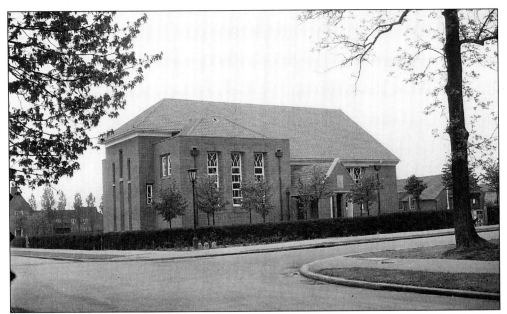

St Francis church in Parkway soon after its consecration in May 1935. Louis de Soissons' original design for the Anglican church unveiled in January 1929 was for a much larger building with a square tower in the north west corner but lack of funds delayed building and caused the design to be modified.

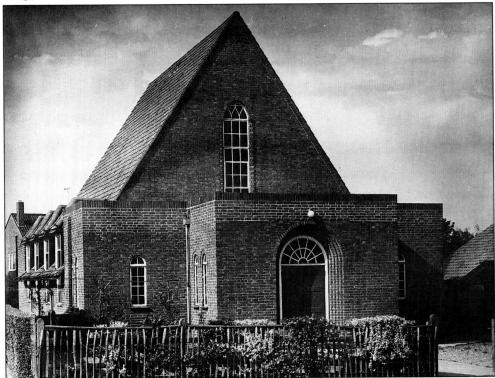

The Congregational Church in Woodhall Lane which was completed in October 1938 replaced the original wooden church on the right of the picture opened by Ebenezer Howard in 1925.

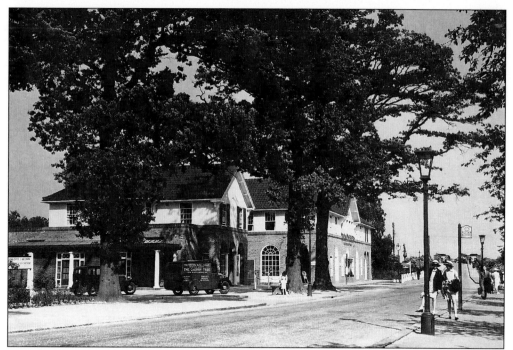

A further sign of the town's growth was the building of this new larger Cherry Tree in Bridge Road, which opened on 23 November 1933. Designed to continue as a community centre as well as a pub it remained the focal point for clubs and societies. In 1947 it hosted 99 banquets and dances and 22 wedding receptions and socials.

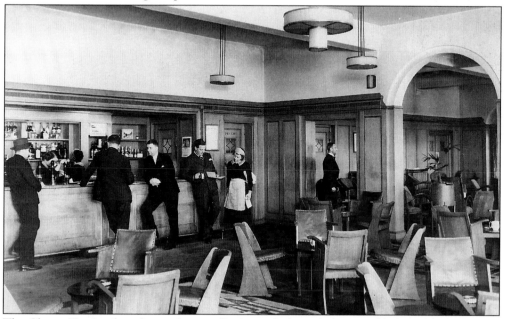

The Cherry Tree's saloon bar with green leather upholstered chairs and light oak panelling. In addition there was a bowling green, games room, restaurant, assembly hall and ballroom, with a children's pavilion in the gardens. Use declined in the 1980's and in 1991 the Cherry Tree was demolished and replaced with a Waitrose supermarket built behind the original facade.

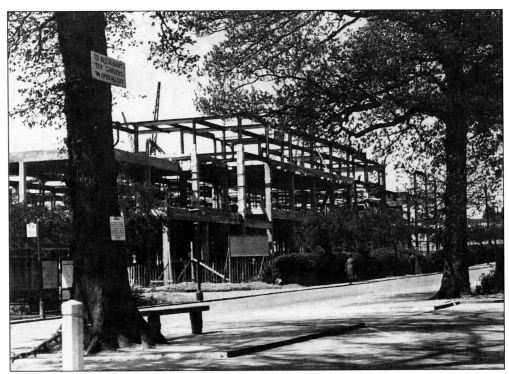

The new Welwyn Department Store building under construction in 1938. Built by Welwyn Builders, the steelwork was supplied by Dawnays and all the bricks were made in Welwyn Garden City.

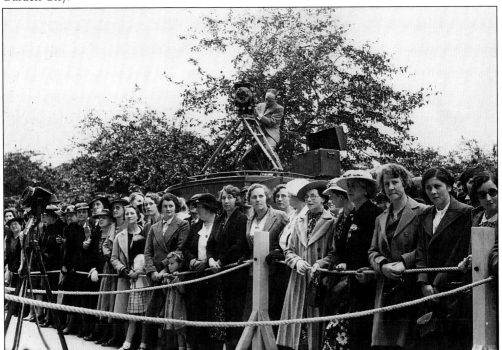

Crowds gather outside the Stores on the official opening day 26 June 1939.

Sir Theodore Chambers, the Chairman of Welwyn Garden City Limited, with Lord Harmsworth who opened the new building.

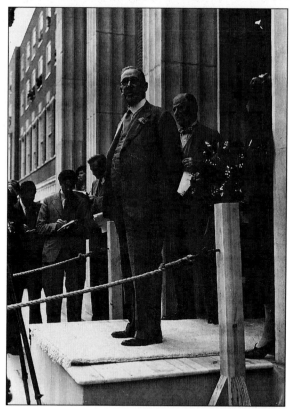

Welwyn Department Store shortly after opening in 1939 with the original white Welwyn Stores in the background. With over 80,000 square feet of selling space the new store claimed to be the largest shop in Hertfordshire. It remained an independent department store until bought by the John Lewis Partnership in 1983.

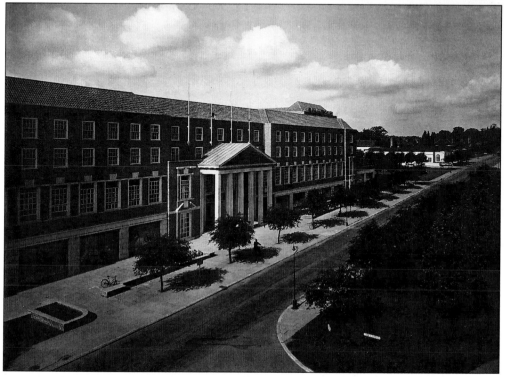

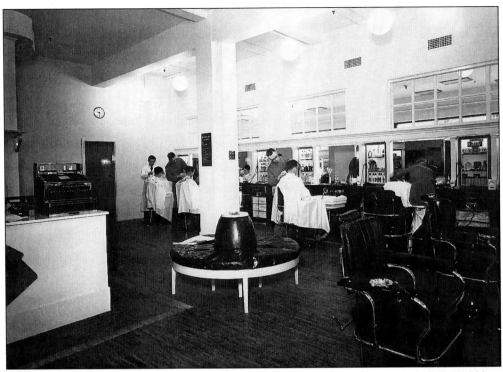

The men's hairdressing department on the ground floor in Welwyn Department Store, 1939.

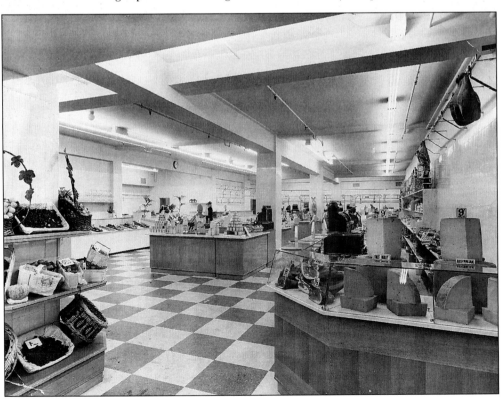

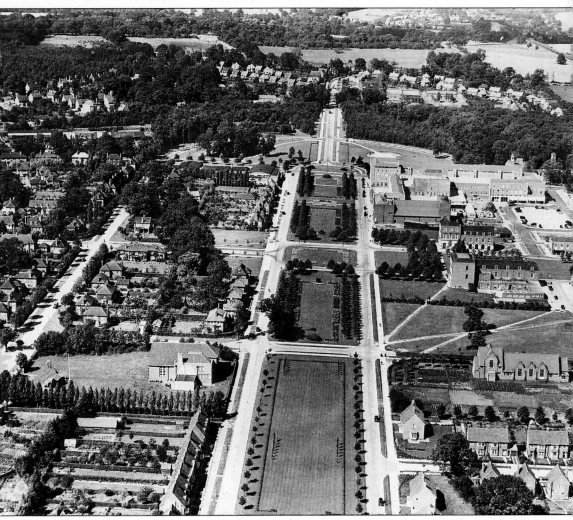

An aerial view of the town centre in 1939 showing the newly completed Welwyn Department Store. Note the road going straight across the still heavily wooded Campus and then curving off to the right.

Opposite: The new food hall in the Department Store in 1939. Designed to be light and modern the counters were pale oak with marble tops. 1400 feet of fluorescent tube lighting in 3 parallel rows – one red tube and two blue, gave the appearance of artificial daylight. The basement housed a refrigeration plant with separate freezing rooms and cool rooms.

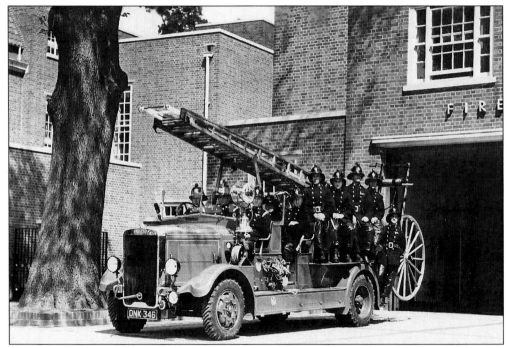

The town's Fire Brigade with their new Leyland Pump in 1938. Founded in 1922 the Fire Brigade initially consisted of Captain James and four volunteers with a handcart and 30 feet of hose. The Hatfield engine was used in a real emergency until the first motor pump was purchased in 1928.

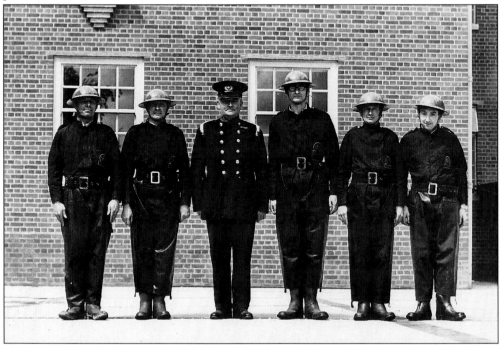

Members of the Auxiliary Fire Service with Chief Officer Mr J Dougherty outside the fire station next to the Council Offices in Bridge Road in July 1939.

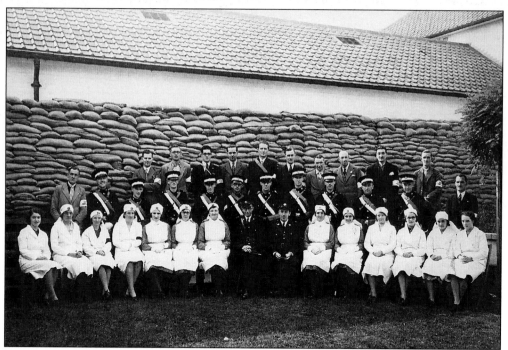

Peartree Boys' Club in Peartree Lane was used as a first aid station throughout the war and this photograph shows the St John Ambulance Brigade volunteers outside the heavily sandbagged building.

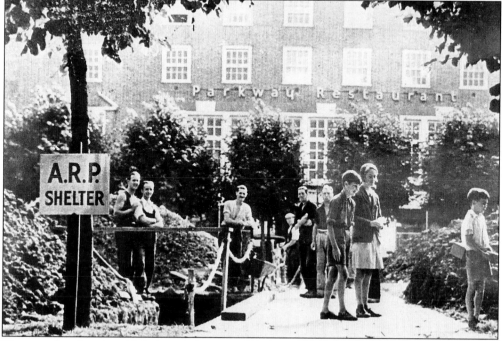

Constructing the air raid shelter at the top of Parkway opposite the Department Stores. The little boy on the extreme right of the photograph is carrying his gas mask. Work on building shelters in the town began in earnest as early as September 1938 after the Munich crisis.

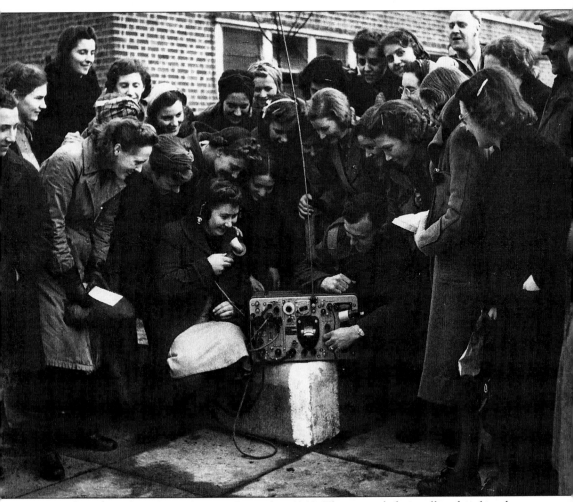

Troops visiting Murphy Radio on 7 December 1942. The young lady is calling her friend over a wireless set she helped to make. Such visits were seen as a general morale booster for the factory workers whose efforts at Murphy's producing walkie talkies, radios and electronic listening devices played a vital role in the war effort.

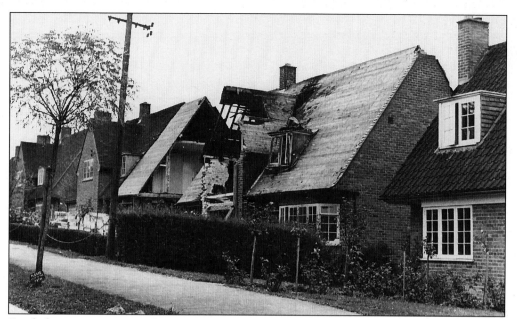

Bomb damage to nos. 6 and 8 Coneydale in October 1940. Welwyn Garden City lay between the targets of Welwyn viaduct, the A1 and the De Havilland factory at Hatfield. It was comparatively fortunate in that although it received some off target bombing only 4 people lost their lives.

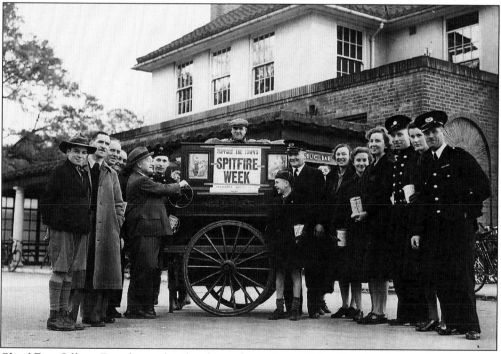

Chief Fire Officer Dougherty, his family, and members of the Fire Service on the right with Ernest Selley and others outside the Cherry Tree at the start of Spitfire Week, 26 October – 2 November 1940. The barrel organ was pushed around the town in house to house collections which together with dances, bring and buy sales and other events raised £1,500.

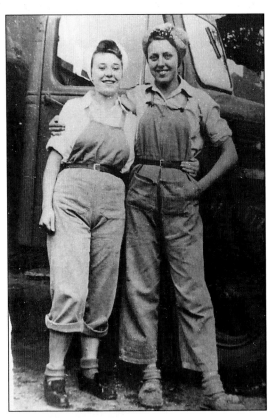

Two members of the Women's Land Army at Hatfield Hyde *c.* 1948. Land Army girls worked on local farms and some were billeted with Welwyn Garden City families. A number stayed on and worked for a few years after the war ended.

A VE Day party in Sandpit Road in 1945. The accordion player is Mr Dickie Wallace. Parties were held throughout the town with dancing on the Campus in the evening and a bonfire in Stonehills.

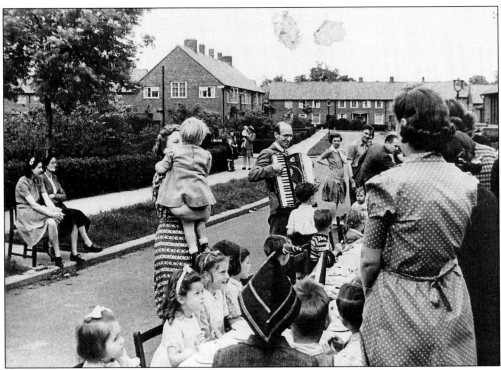

Four

Industry

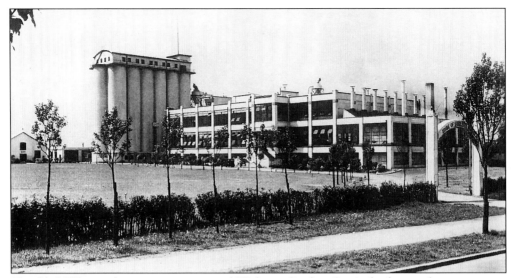

Shredded Wheat, the most important of Welwyn Garden City's food manufacturers, came to the town in 1926, attracted by the healthy environment. The building quickly became a landmark and is now listed. Annual sports days were held on the green open space beside the factory.

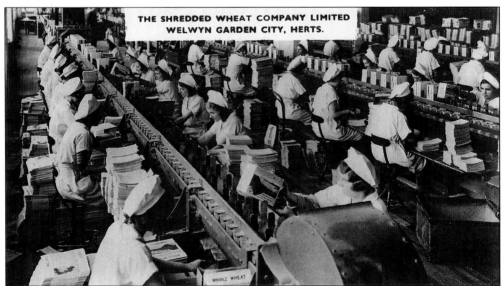

THE SHREDDED WHEAT COMPANY LIMITED
WELWYN GARDEN CITY, HERTS.

Shredded Wheat's packing lines where the finished product was hand packed, having been carried hot from the ovens in long wire trays. There was an annual award for the fastest packer, the first in 1926 going to Kate Potter who packed 32,400 biscuits in a working day.

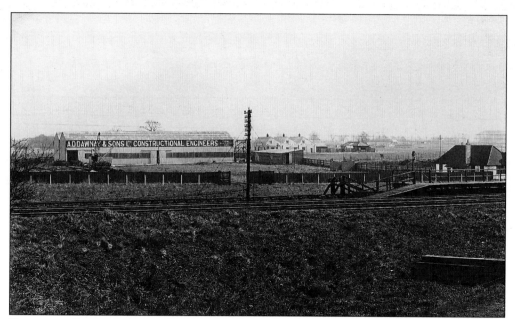

Dawnays, a Battersea firm making steel girders who were in the town from 1923 until 1969. During that time they supplied much of the steel for the town's buildings. This photograph shows their earliest factory alongside the main railway line, with Welwyn Laundry in the background.

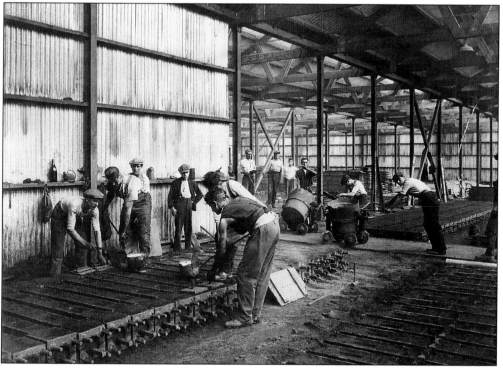

Welwyn Foundry Company Ltd which occupied a large site in Bessemer Road. From 1927 they specialised in the manufacture of the cast iron rain water pipes, drain pipes, guttering and street signs that were needed in the town.

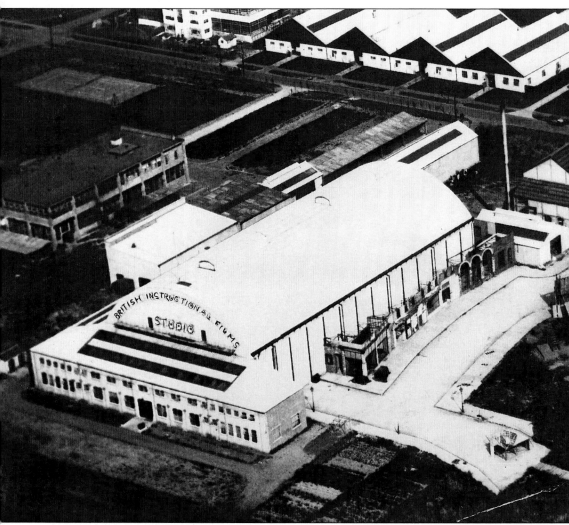

The Film Studios in Broadwater Road showing one of the large outdoor sets constructed at the side of the building. Opened on 8 November 1928 this new purpose built studio for British Instructional Films was where over seventy films were made, including in 1932 the famous *I was a Spy*. Local townspeople were sometimes used as extras and film stars could often be seen in the Cherry Tree during breaks in filming. The studio closed in 1950 and the building was occupied by Polycell for 40 years before its demolition in 2007.

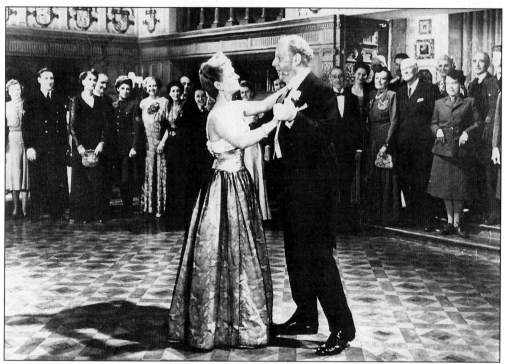

A scene from the film *I Live in Grosvenor Square* during the production at Welwyn Studios in 1945, directed by Herbert Wilcox. The dancers are Anna Neagle and Robert Morley.

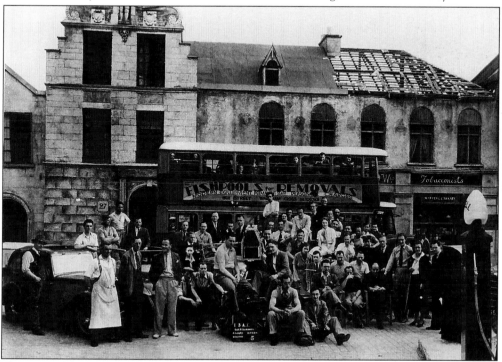

The crew of the film *Double Error* directed by Captain Walter Summers in front of the outdoor set at Welwyn Film Studios.

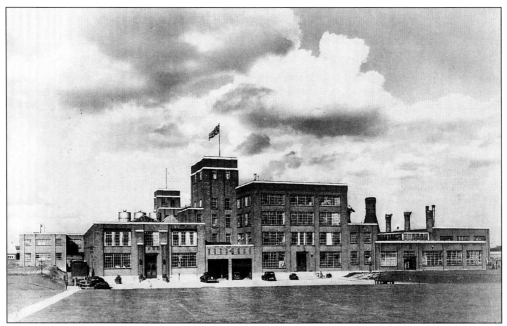

Norton Abrasives Ltd, makers of grinding wheels who came to the town in 1931. It was the first British base for the American company, chosen because it fitted their president's ideal of a "locality where the workers will have good homes, good surroundings and room enough for a garden".

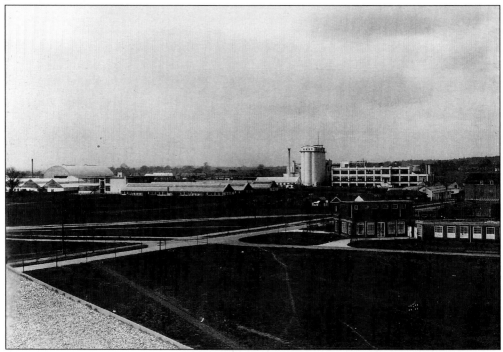

The view from Norton's roof in 1931 showing in the background the Shredded Wheat factory, rows of sectional factories and the Film Studios; and in the middle ground the sub station and offices of Welwyn Garden City Electricity Supply Company.

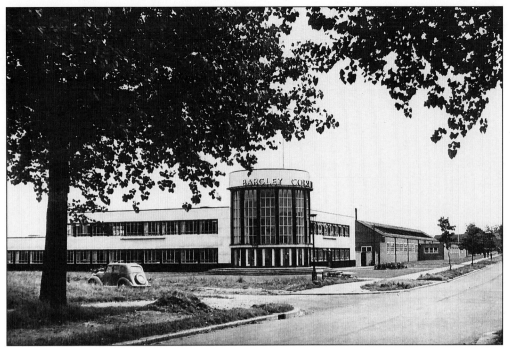

The attractive 1939 factory on the corner of Bridge Road East and Swallowfields of another American manufacturer, Barcley Corsets. Professional "Corsetieres" would visit clients in their own homes and garments would be individually made to measure. Falling demand led the company to leave the town in 1972, and the building was demolished in 2000, much to the disappointment of many of the town's residents.

The staff of Welwyn Builders Ltd in about 1928, almost certainly on the annual works outing, a feature of pre-war employment.

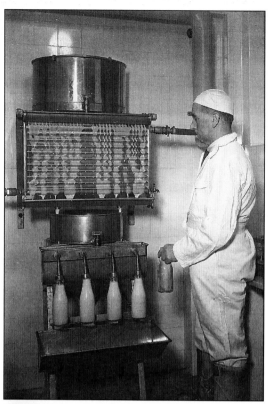

Interior of the bottling room at Welwyn Department Stores Dairy in 1939. The Dairy had formerly been in the barn at Lower Handside Farm in Handside Lane, now the Barn Theatre.

Welwyn Stores Dairy and delivery staff in the yard behind the Department Store in 1939. Milk for processing came from local Hertfordshire farms, often delivered in churns by horse and cart.

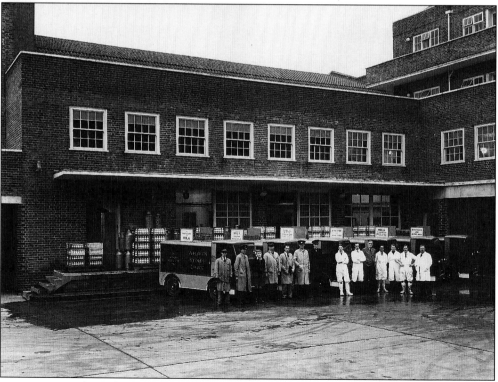

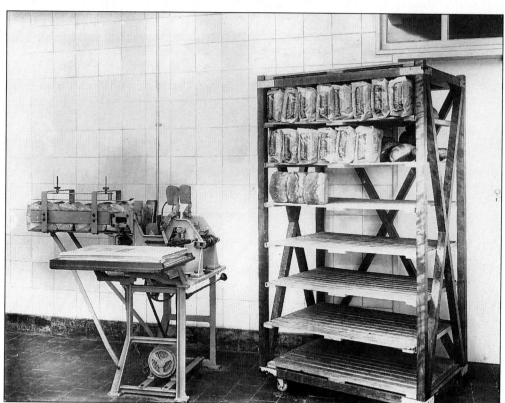

Interior of Welwyn Bakery in Bridge Road East which opened in 1926. The emphasis on hygiene with white enamel tiles throughout, and the advanced technology attracted many visitors. The photograph shows an early mechanised bread wrapping machine with "Millennium" loaves made with unbleached and untreated flour.

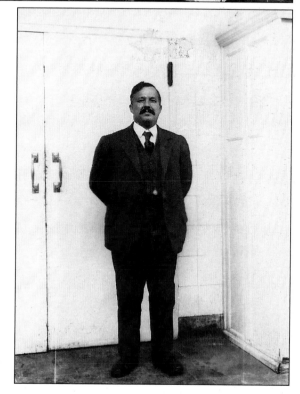

Mr A Curry, manager of Welwyn Bakery who won many cups and shields in the late 1920s and early 1930s. Bakery produce was sold in Welwyn Stores with such delicacies in 1928 as fresh cream pastries at two pence each and "choclatines" seven for a shilling.

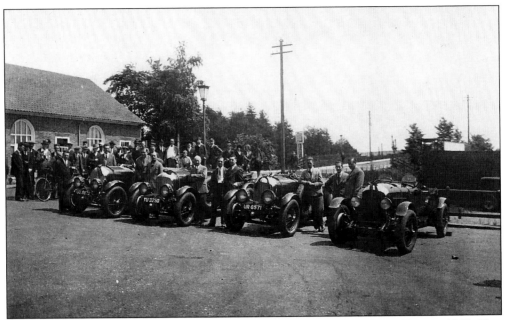

Captain Birkin's racing Bentleys outside Bridge Hall next to the Cherry Tree in 1930. Tim Birkin pioneered the use of superchargers, for racing engines and won the Le Mans Grand Prix in June 1929.

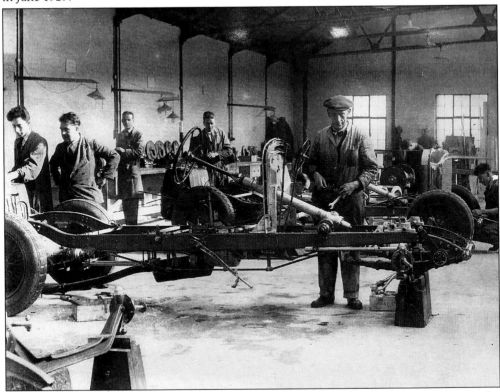

Interior of the sectional factory in Broadwater Road in 1929 where the work on perfecting the Bentleys' supercharged engines took place.

"Sectional Factories", which were an ideal way for the Company to attract much-needed industry to the town. A manufacturer could rent as little or as much of a building as he needed and could then expand as his business grew.

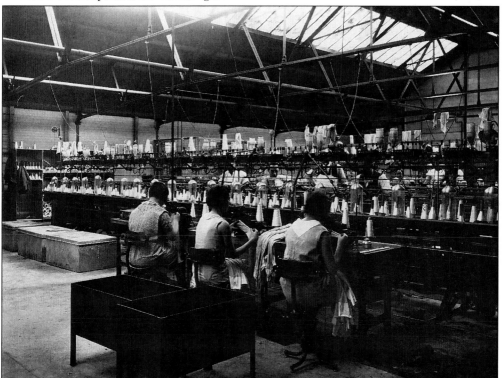

Fedden and Bond's silk stocking factory which was housed in one of the sectional factories in Broadwater Road from 1930-1939. The knitting machines illustrated were 15 yards long with 48,000 moving parts. The slightest expansion or contraction of the metal parts would ruin the stocking so the factory temperature was maintained at 70°-80°F all year.

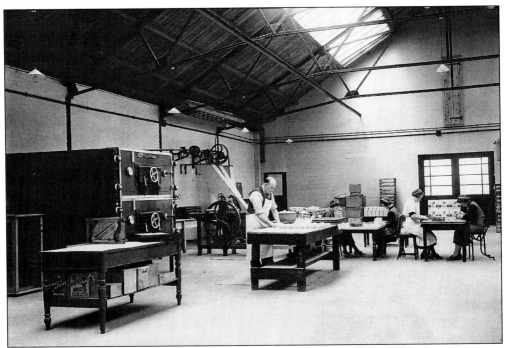

Interior of the Bickiepeg's factory which manufactured nursery and invalid food as well as the Bickiepeg teething rusk. This was a hard, densely moulded rusk two inches long and a pencil's width diameter, with a length of ribbon attached to prevent its being accidentally swallowed.

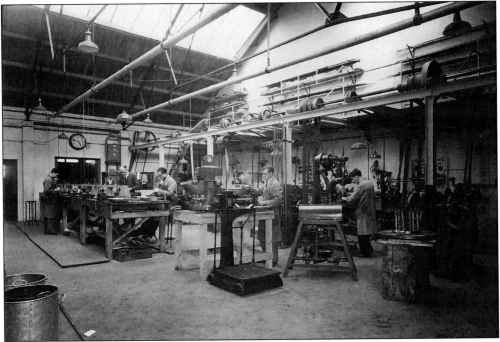

The Tewin Road factory of Pocklington and Johnson of London. Manufacturers of helical and coil springs they opened a branch in the town in 1936. A family firm, they were sufficiently enlightened to allow their employees to job share.

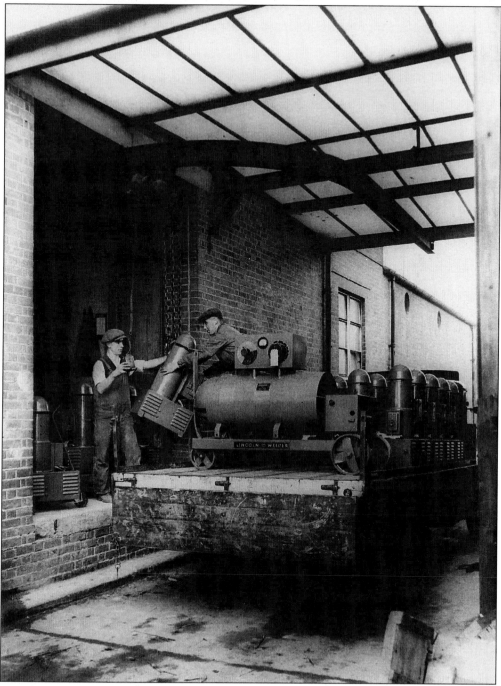

Lincoln Electric, which was another major manufacturing company to establish in the town in the 1930s. From a small factory in Broadwater Road they expanded to become one of the largest manufacturers of DC arc welding units in the UK. Their invention of an electrode which would weld armour plate was to prove vital during World War II.

The first factory of Cresta Silks in Broadwater Road following their move to Welwyn Garden City from Cornwall in 1929. Founded by Tom Heron, the firm made hand painted silk fabrics and "garments for discriminating women at affordable prices". Fabric designs were often by eminent artists such as Raoul Dufy, Paul Nash and Heron's son Patrick.

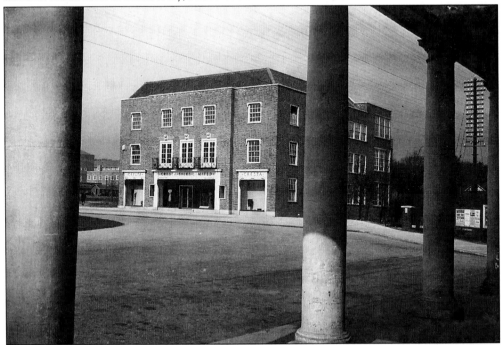

Cresta Silks' 1938 factory in Howardsgate photographed from the railway station entrance. The company earned a wide reputation with over 80 shops throughout England. In 1954 the business moved into Welwyn Department Store. It was later taken over by Debenhams and ceased trading in the late 1970s.

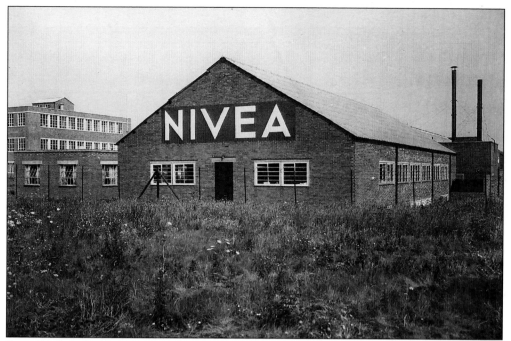

Beiersdorf's early factory in Bessemer Road. The company moved to England from Hamburg in 1931 and made surgical plasters and wound dressings as well as "Nivea" products.

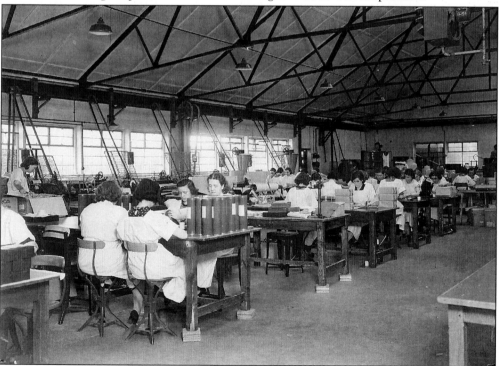

Interior of the Beiersdorf factory in the late 1930s. At the outbreak of World War II they changed their name to Herts Pharmaceuticals Ltd and expanded into pharmaceutical research. In 1952 they became part of the Smith & Nephew group, eventually leaving the town in 1982.

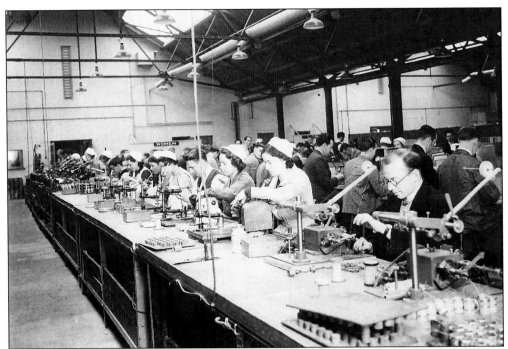

Coil winding and other component manufacture at Murphy Radio's sectional factory in Broadwater Road which opened in 1928. Frank Murphy pioneered many improvements in the radio industry with smaller and more reliable radios sold through a network of committed dealers. By 1939 Murphy Radio was one of the top six companies in its field.

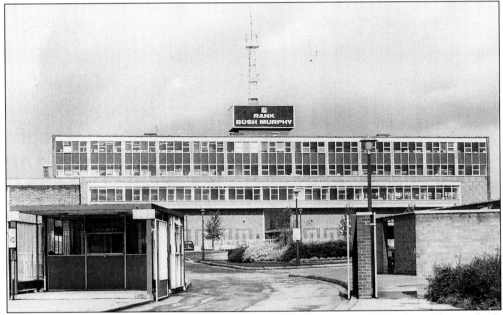

The advent of television and developments in electronics necessitated this larger factory built for Murphy Radio in Bessemer Road in the 1950s. In 1962 Murphy Radio became part of the Rank Organisation, moving to Ware in 1970. The site was taken over by Rank Xerox and this building was demolished in 1995.

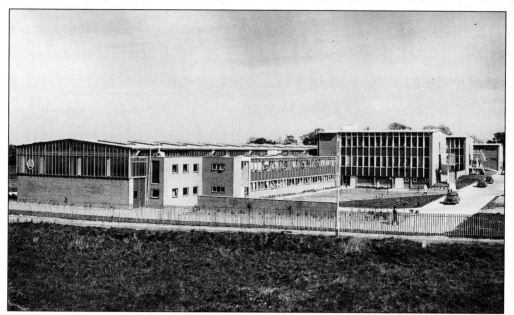

ICI Plastics Division which came to the town in 1938 and grew to be one of the largest employers with a site off Bessemer Road of over 60 acres. This photograph shows the Technical Service and Development Laboratories *c.* 1960. The company's departure in 1982 was a severe blow but their large site was re-developed as the Shire Park business centre.

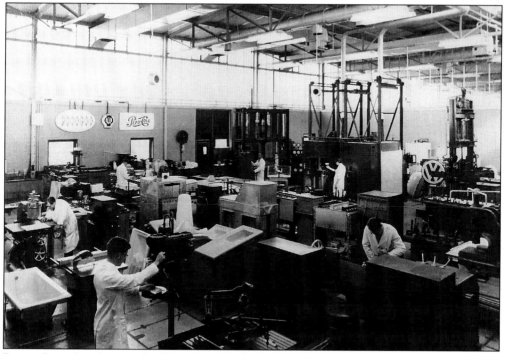

Research vital to the growth of the plastics industry took place in Welwyn Garden City. During the war "perspex" for windows and canopies in war planes and plastics for explosives were developed. This photograph shows ICI's post-war Thermoplastic Shaping Shop experimenting with plastics for baths and advertising signs.

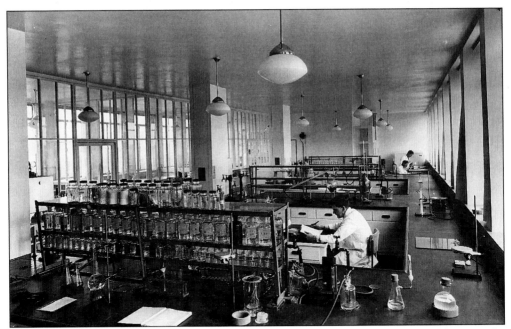

The interior of one of the research laboratories in Roche Products original building on the west side of Broadwater Road. Designed by the Swiss architect Otto Salvisberg in 1937 as the company's UK headquarters, the building is now listed.

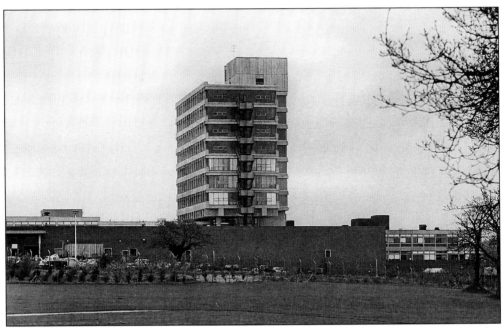

Another leading pharmaceutical company, Smith Kline Beecham moved to Welwyn Garden City from south-east London in 1959. Their purpose built laboratories and offices in Mundells were completed in 1963 when the tower block shown in the photograph was the tallest in the town.

Five

Community Spirit

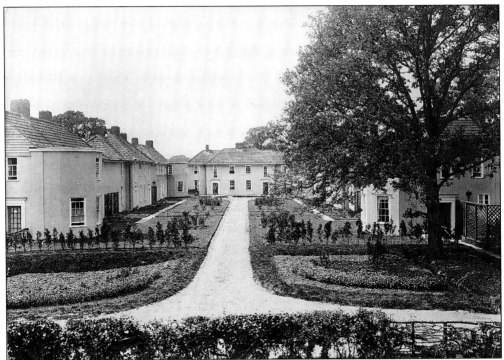

Handside Close in the early 1920s. Much of Welwyn Garden City's housing is in cul-de-sacs as it was felt that building houses in such small groups promoted the idea of community.

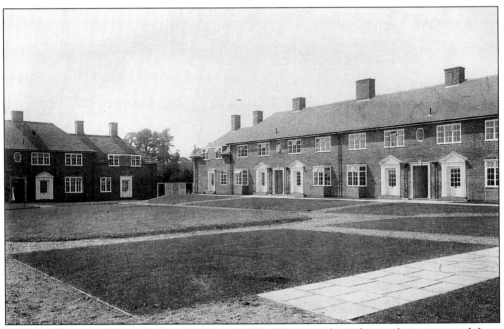

Parkway Close which was built in the later 1920s. The same basic house design is saved from being monotonous by the use of slightly different door and window styles and by varying the roof line.

Peartree Court, one of the earliest developments in the Peartree area, designed to provide rented housing for factory workers. For speed of erection and low cost the houses were built of concrete on a steel framework. Unfortunately, movement in the clay foundations caused the walls to crack and the houses also suffered extreme condensation problems leading to their demolition in 1983.

Autumn Grove *c.* 1959. Expansion of the town after 1948 under the Development Corporation was to a plan drawn up by Louis de Soissons, which maintained continuity of design. Houses continued to be built in closes with open plan front gardens and wide grass verges, but few garages – hence the car-parking problems of today.

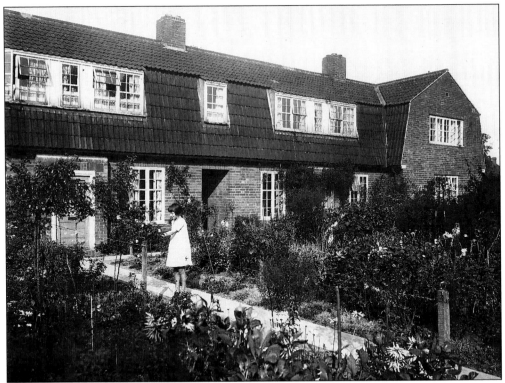

These houses in Applecroft Road were some of the first council houses built in the town by Welwyn Rural District Council in 1922. Good working class housing was a necessary enticement for new industries.

Number 5 Guessens Road on the extreme left of the picture, originally the home of Ebenezer Howard. Note the track of the light railway in the foreground.

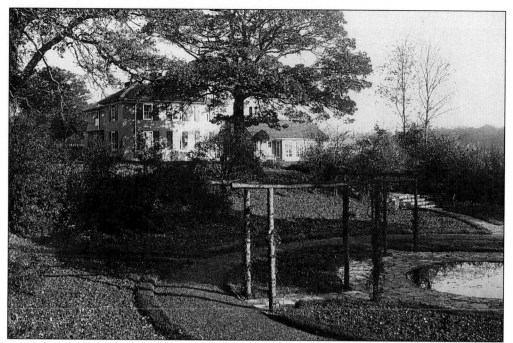

Number 9 Guessens Road designed by Louis de Soissons in 1922 for the Chairman of Welwyn Garden City Ltd, Sir Theodore Chambers. The house had five bedrooms, two for live in maids, and space off the sitting room for a wine store.

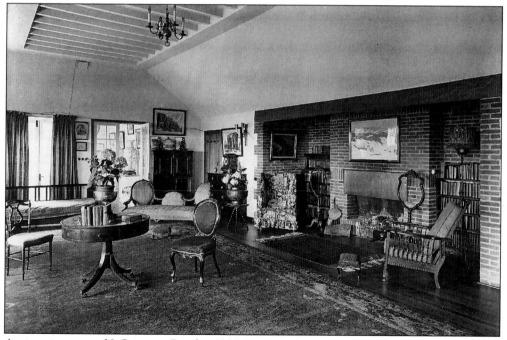

An interior view of 9 Guessens Road c. 1930. In 1939 the town's library moved into the house as the space it occupied in the Council Offices was needed for war work. Although initially a temporary measure, the library remained here until moving to the new college building on the Campus in 1960.

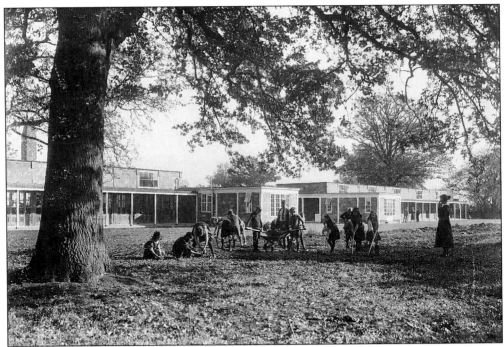

The infant and junior departments of the first school in the town, Handside School in Applecroft Road, which was built in 1922 at a cost of £9030. There was a children's garden and playing fields and the classrooms had large doors which could be slid open in summer.

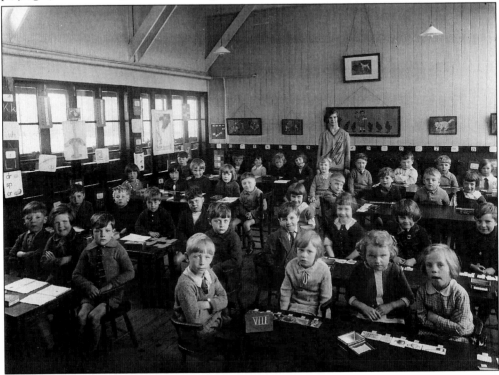

Class 8 of Handside School and their teacher, Miss Southwell, in 1930.

Class 3A of Handside School in 1937 with the Headmaster, Mr Nichol and teachers, Miss Ward and Miss Wynn.

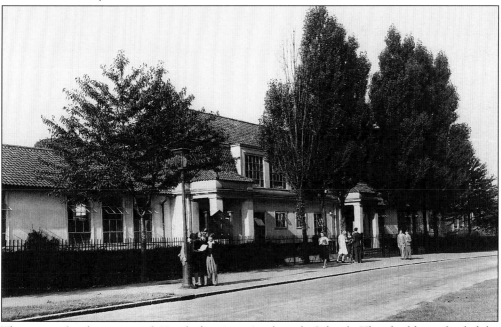

The more familiar view of Handside, now Applecroft School. This building, funded by Hertfordshire County Council, was constructed in front of the earlier one and opened in November 1926. With accommodation for approximately 800 pupils, the advanced design incorporated special rooms for art, woodwork and laundry and a central hall with underfloor heating.

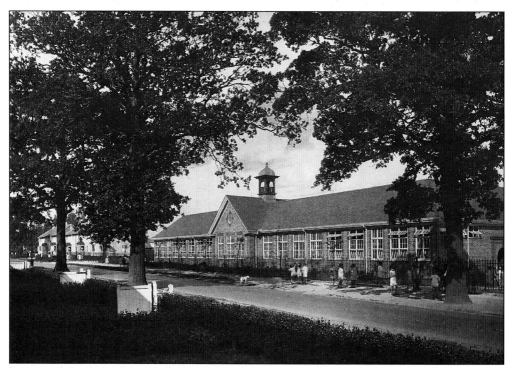

Peartree School which opened in 1929 for children ages 5-11. The first headmistress was Miss Laura Sing who was well remembered for her kindness and for rewarding children with sweets from a large jar.

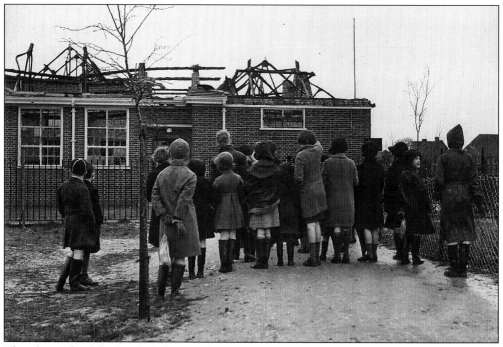

The aftermath of the fire at Parkway School in March 1939 which was later proved to be arson. The school was re-built within a year.

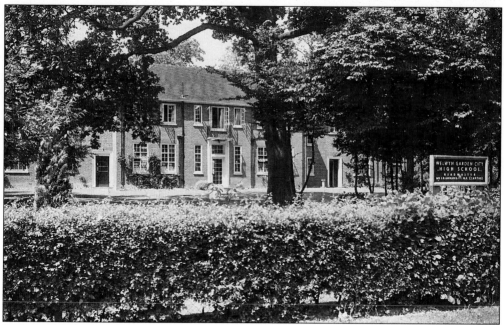

Welwyn Garden City High School started as a private venture in a house in Elmwood in 1928. It grew rapidly moving to this site in Digswell Road in 1929 and was renamed Sherrardswood School in September 1939. In 1995 the school centralised all of its departments at Lockleys in Welwyn. This building was demolished in 1995 and the site re-developed for housing and named Scholars Mews as a reminder of its former use.

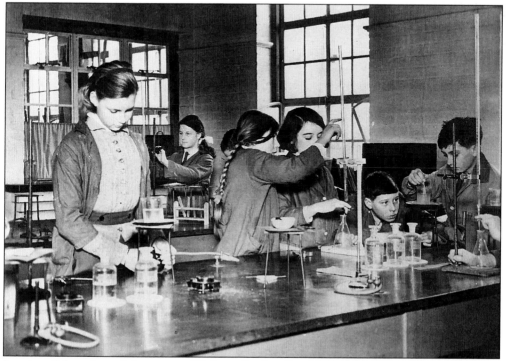

Interior of the science laboratory at Welwyn Garden City High School in the late 1930s.

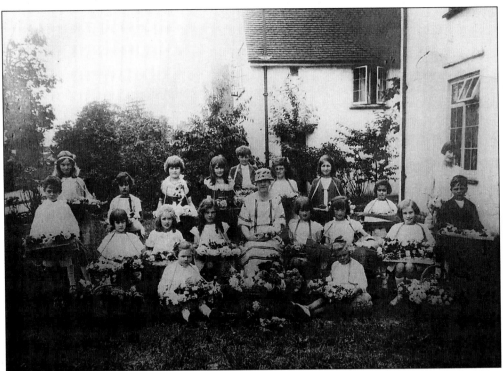

Mrs Edith Haggis and pupils of the Alpha School outside 70 Handside Lane for Alexandra Rose day in 1924. Mrs Haggis originally started her school in a hut on the Campus, naming it Alpha as it was the first in the town.

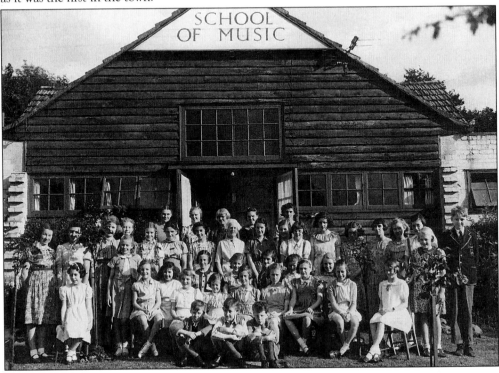

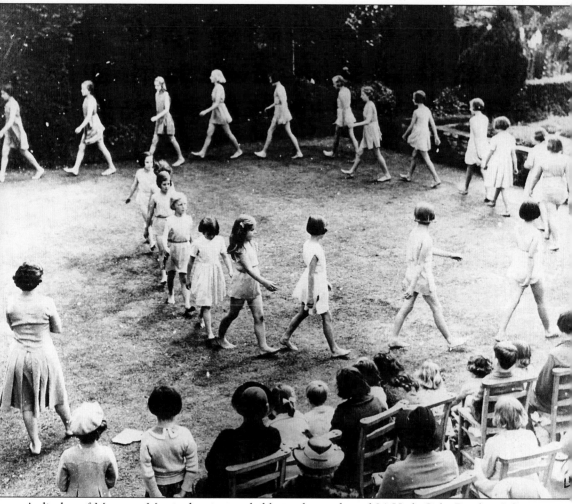

A display of Margaret Morris dancing probably in the garden of 24 High Oaks Road in July 1939. Classes in this style of dancing were held at the Alpha School.

Opposite: The Welwyn Garden City School of Music, part of the Alpha School, in the building on the corner of Elmwood and Applecroft Road which opened in 1927 and was later occupied by the Royal British Legion. Monica Court flats have since been built on the site.

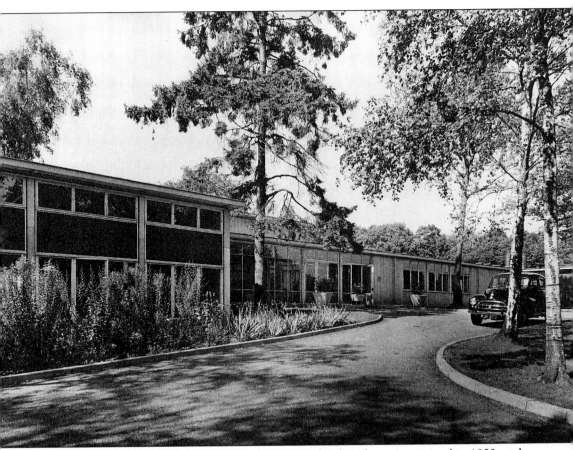

Templewood School which was the first post-war school in the town, opened in 1950, and was built using a prefabricated kit based on a frame of steel construction with concrete cladding. Many schools in Hertfordshire were built using this method as a response to the shortage of building materials and skilled labour after the war.

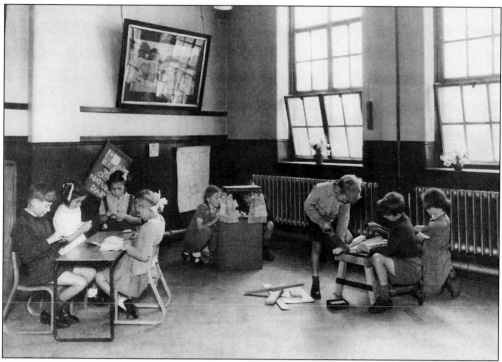
A class in Ludwick School in the early 1950s.

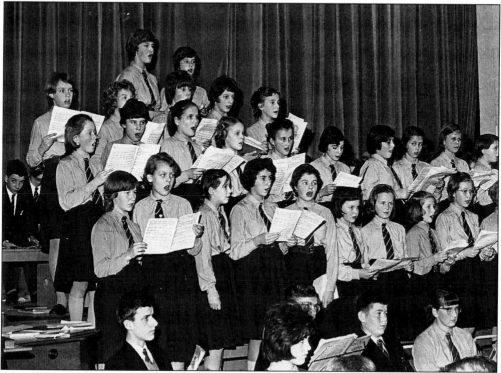
The Grammar School, now Stanborough School, junior choir in concert in December 1962. This was the first purpose built secondary school in the town and opened in September 1939.

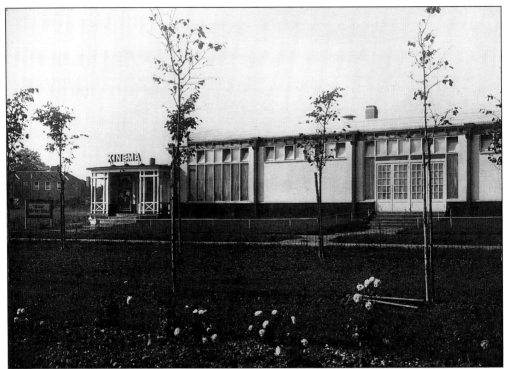

The Kinema in Parkway Hall, an extension of the original Welwyn Stores. Arthur Guest, an early resident who came to the town from Australia, began silent film shows here in 1924, twice weekly with music provided by a local pianist and violinist. It remained the town's only cinema until the Welwyn (later Embassy) Theatre opened in Parkway in 1928.

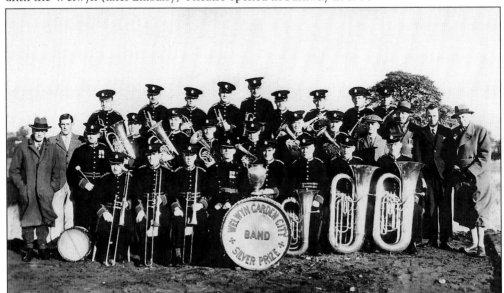

Welwyn Garden City Town Band in the 1950s. During the recession of the early 1930s families moved to the town from Wales and the North, a number of whom were keen brass players. Largely through the efforts of John Hart (3rd from left front row), they joined together in 1934 to form a brass band which still gives pleasure today.

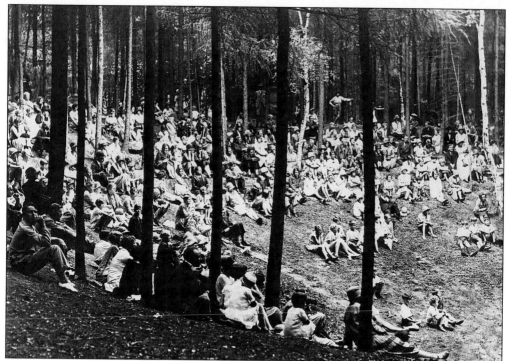

Some of the audience at one of the Shakespeare productions in the Dell in Sherrardswood in the 1920s. Over 1500 people attended *A Midsummer Night's Dream* in 1925 and in 1928 there was a suggestion of erecting a permanent outdoor theatre there, although it was never constructed.

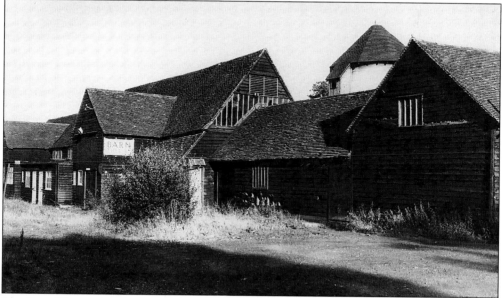

The Barn Theatre in Handside Lane, converted from the Lower Handside Farm barns in 1931, and apart from a short break during the war in use ever since. The town's remarkable enthusiasm for amateur drama began as early as 1921 with the first Drama Festival, still a popular annual event, being held in 1929.

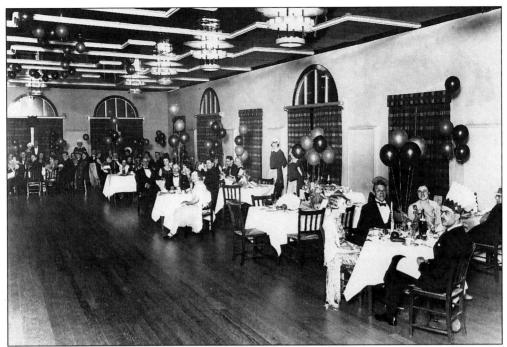

One of the many dinner dances held in the Bridge Hall extension of the Cherry Tree, which played such a large part in the social life of the town.

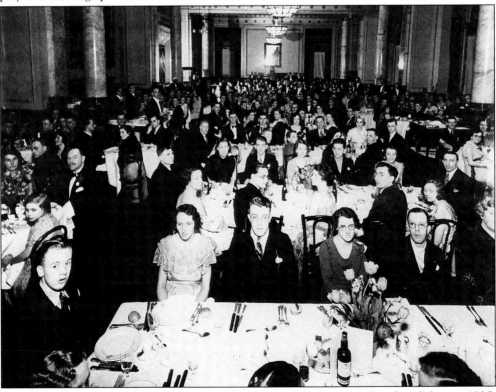

Murphy Radio Company's annual dinner at the Wharncliffe Rooms in London, February 1935.

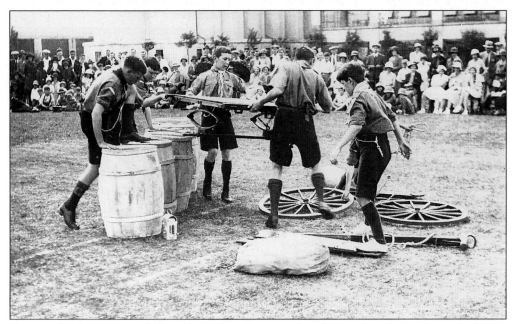

A scout display at one of Shredded Wheat's sports days believed to be in the early 1930s. Shredded Wheat's silos are in the background. Held annually at the end of August, these sports days quickly became one of the town's favourite events.

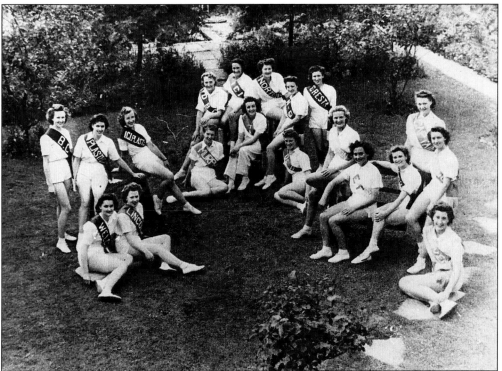

Members of Eileen Fowler's Parade of Youth and Beauty pose with Miss Fowler c 1941. Most of the major factories in the town had their own keep fit team and displays were given at local sports days and at events on the Campus.

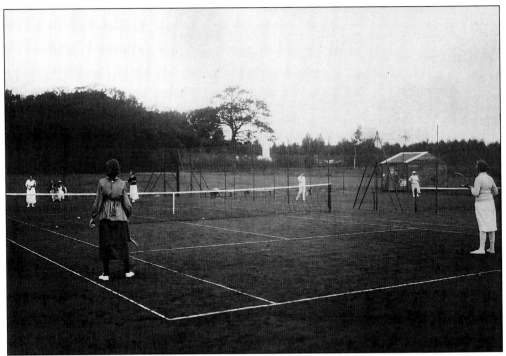

A tennis match in progress during the early 1920s. As early as 1921 two courts were made where Stonehills is now and a tennis club was formed run by Mr M Jennings with organised tournaments and tennis dances.

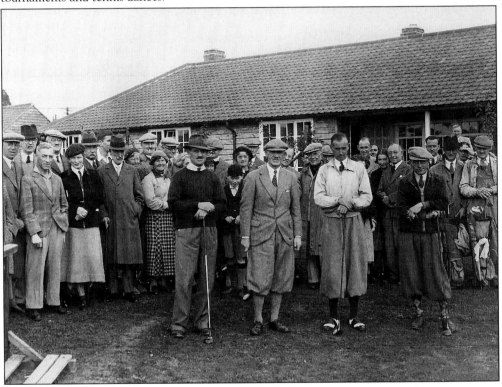

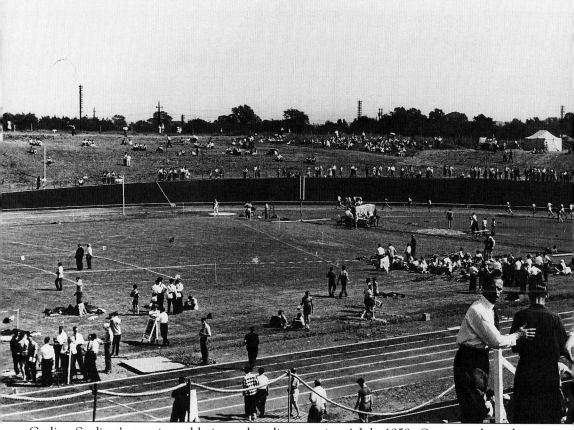

Gosling Stadium's opening athletics and cycling meeting 4 July 1959. Constructed on the site of a disused gravel pit, the stadium is named after the first chairman of the Development Corporation, Reg Gosling.

Opposite: Players assembled on the first tee of Welwyn Garden City Golf Club for a pro-am match, 11 October 1936. From left to right: M. Gear Evans and Abe Mitchell (pro), Verulam Golf Club; L A Titterington (pro) and Malcolm Sharp, Welwyn Garden City.

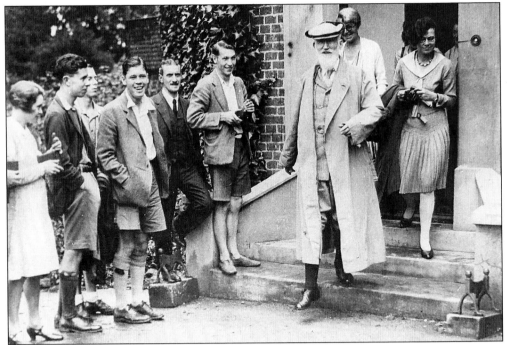

George Bernard Shaw leaving Digswell House after the Independent Labour Party conference in August 1930. With its attractive parkland setting the House became a popular venue for a wide variety of conferences with several hundred being held there from 1928 onwards. It even became known locally as the Conference House.

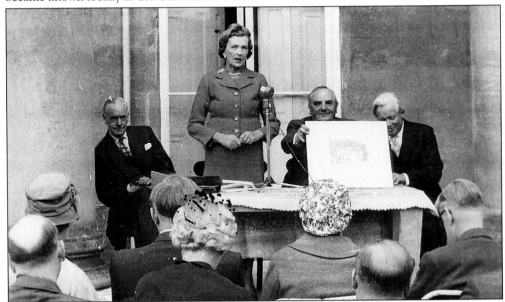

The official opening of Digswell House as an Arts Centre, 29 May 1959. Left to right: Henry Morris, Countess Mountbatten, Gordon Maynard and D Hardman. Around 16 artists lived there at any one time, following Morris's ideal of pursuing their own work whilst also serving the community. Rising costs forced the Arts Trust to leave Digswell House in 1984 by which time it had been home to over 140 artists, some of whom became world famous.

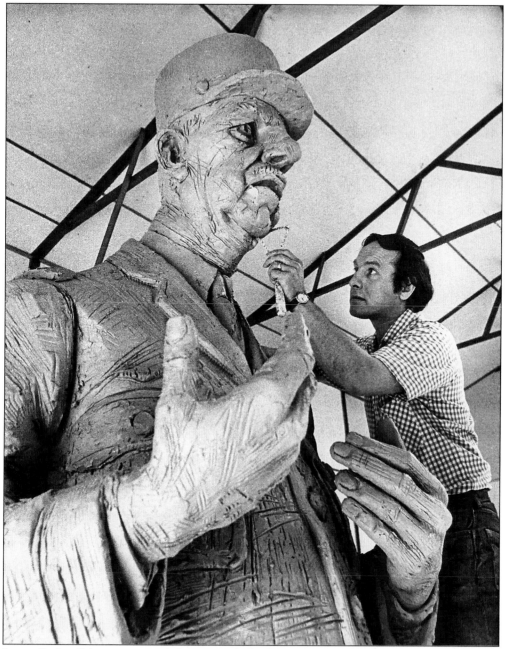

James Butler RA, now one of the country's leading portrait sculptors, at work at Digswell House on his statue of General de Gaulle for an exhibition at the Tate Gallery. Digswell was particularly suited to sculptors who need spacious and tall studios which are not easy to find.

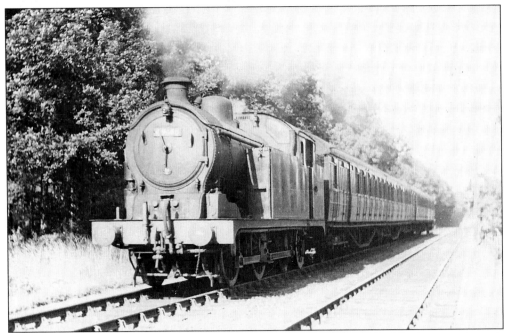

A Welwyn Garden City to Luton train in Sherrardswood, August 1957. The line ran through some very attractive countryside following the Lea valley and was a popular excursion. It closed in the mid 1960s but the route now forms part of the Ayot Greenway footpath.

Sherrardswood in the centre of the town which is a fine example of an ancient oak and hornbeam woodland and provides acres of walks.

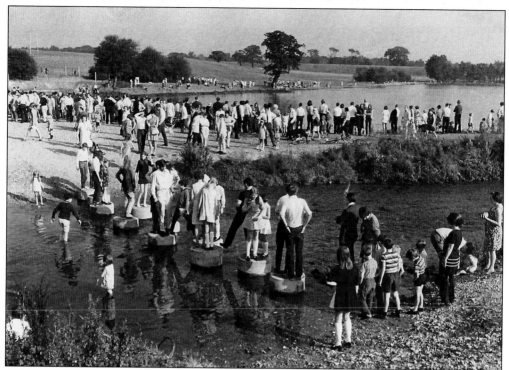

Stanborough Lakes, September 1970. Popular with children, these stepping stones have been replaced with an attractive bridge which is rather less hazardous.

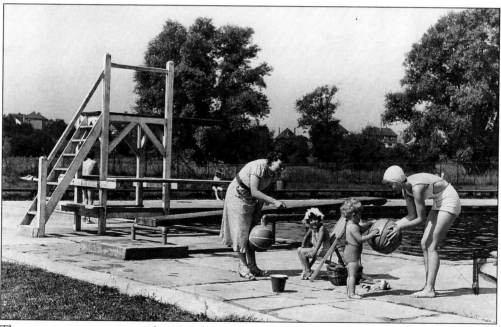

The open-air swimming pool at Stanborough in 1937. In the early days water was diverted straight from the River Lea, so tended to be cold and somewhat green and murky. Despite this the pool was well used and became a favourite spot for summer family outings.

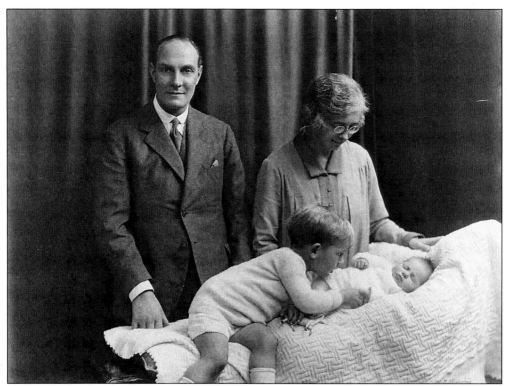

Welwyn Garden City's first doctors, H J B Fry and his wife Dr Miall Smith who arrived in 1922. Sadly Dr Fry died in 1930 but his wife continued to practise, also playing a leading role in the town's Health Association which provided nurses and clinics for a subscription of one penny per week, so important in pre-National Health Service days.

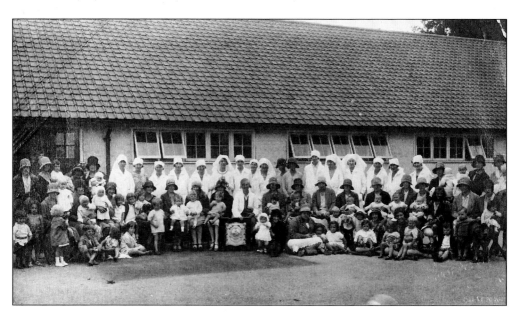

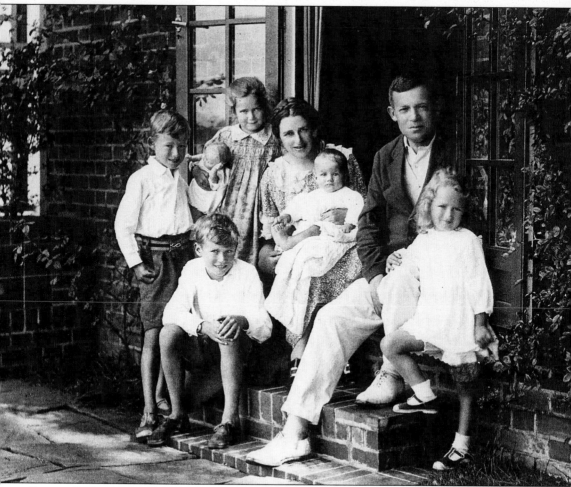

Captain Richard Reiss, his wife Celia and their children at their home in High Oaks Road in 1926. A staunch supporter of Howard and one of the Company's first directors, Reiss and his family also played an enormous role in the sporting and social development of the town. Celia Reiss founded the Health Association and also organised parties to welcome newly arrived residents. The garden on the northern corner of Parkway and Russellcroft Road is in their memory.

Opposite: The child welfare clinic run by the Health Association at Peartree Club House in 1929 when Welwyn Garden City won the William Hardy Shield for high standards of infant care. Dr Miall Smith is in the white coat seated in the front row.

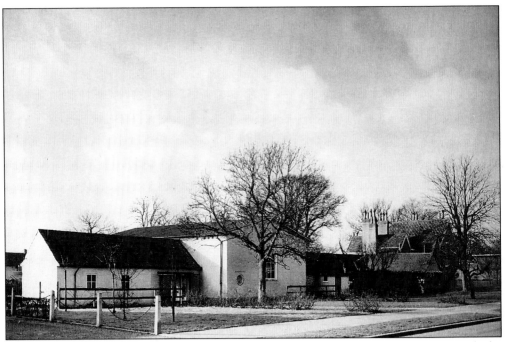

Ludwick Family Club's new building in Hall Grove which opened in February 1954, with the original Ludwick House on the right. The House's stables were converted into a games room and the new hall added on to provide accomodation for the club.

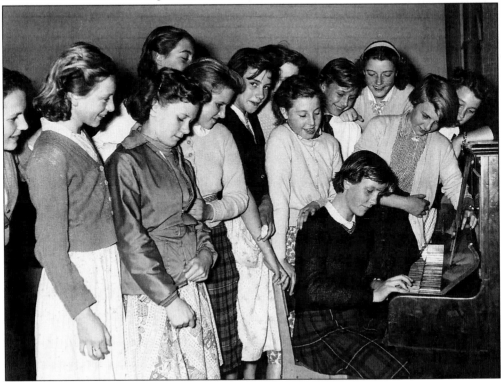

Members of the Girls' Club at Ludwick Family Club in the 1950s.

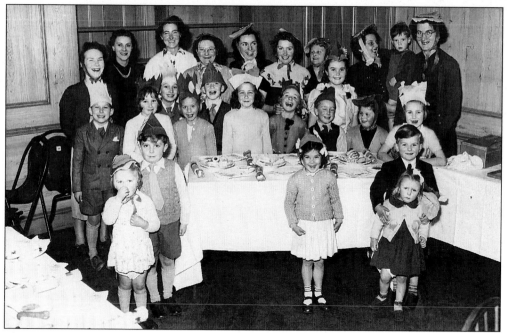

The first children's party held at Hyde House, Christmas 1954. Like Ludwick Family Club, the Hyde Association was started by the Development Corporation for new residents arriving in the town from London in the 1950s.

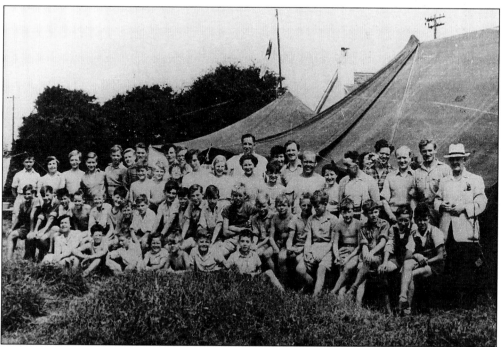

Mackie's Boys' Club Camp on the east coast *c.* 1952 including Mr Mackness on the extreme right. St Francis Boys Club, its formal title, was started by Mr Mackness in 1929 with his own funds to provide physical training activities and an annual summer camp. It remained a popular institution in the town for many years.

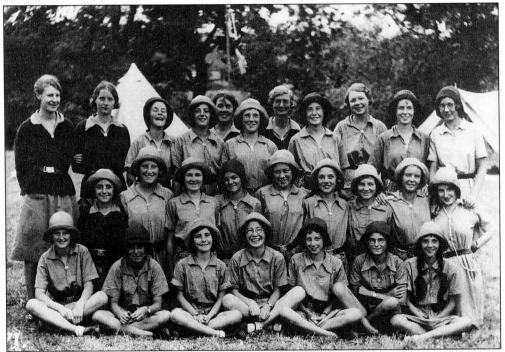

The 3rd Welwyn Garden City Girl Guides at camp in Charmouth 1934. The Guide movement began in the town in 1926 and had 160 members by 1929 when the Guide HQ was opened in Guessens Road. Numbers grew steadily and a second Guide hut opened in Bridge Road in 1935.

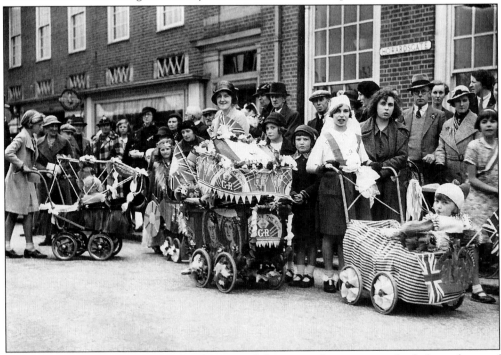

Decorated prams in Howardsgate at the start of the carnival procession which formed part of the coronation celebrations in May 1937.

Six

Post War Expansion

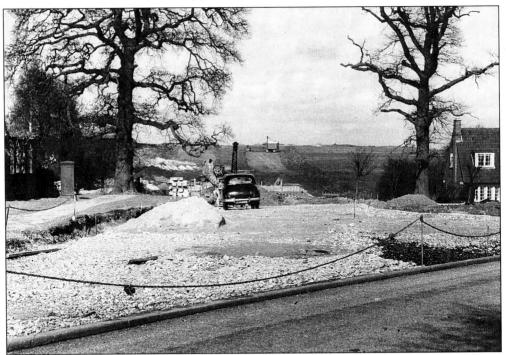

Digswell Road, February 1955. Construction of the extension to open up the northwest area of the town through the gap where numbers 6 and 8 Coneydale were destroyed by bombing during the war. Previously Digswell Road turned right at this point, see the kerb in the foreground, to join Digswell Lane at Digswell Lodge Farm.

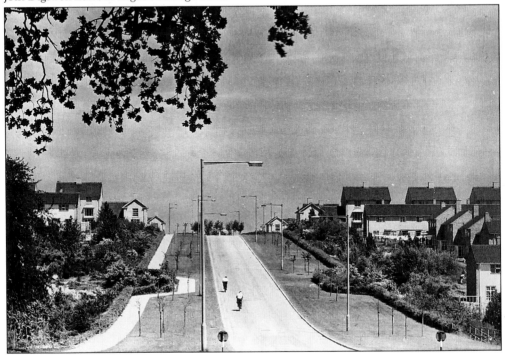

The completed Digswell Road extension leading up to the Knightsfield roundabout c. 1960.

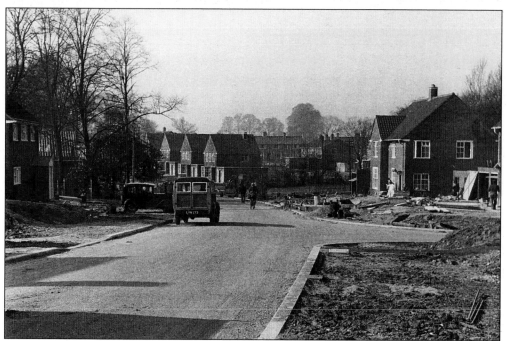

Beehive Lane, March 1953, with houses designed by Louis de Soissons nearing completion as part of the expansion of the south eastern area of the town under the Development Corporation.

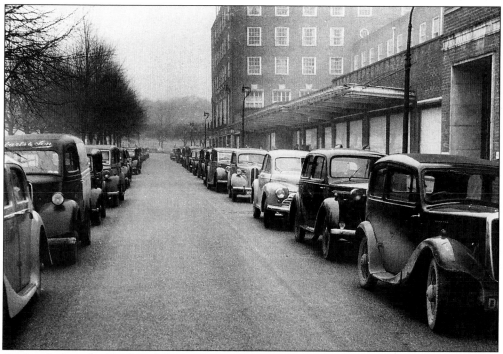

Cars parked on both sides of the carriageway outside Welwyn Department Store in Parkway November 1954. The Christmas rush had just begun and in the days of no yellow lines or traffic wardens motorists could park wherever they liked.

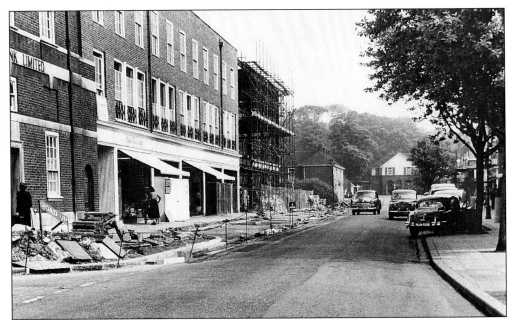

Stonehills in July 1957 with the shops and offices adjoining the original 1930 Lloyds Bank building nearly completed and the next block under construction. Further along on the left is the old Police Station now demolished.

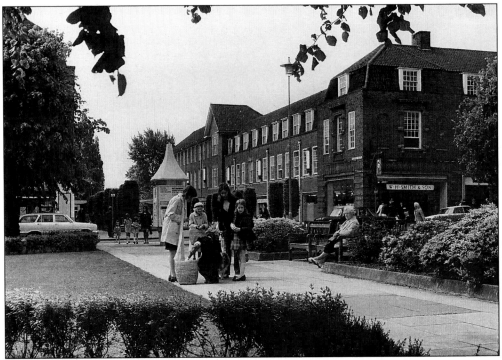

Wigmores South viewed from Howardsgate in June 1972. The construction of shops and offices in Wigmores South and Church Road in 1960-61 completed this section of the town centre first begun in Howardsgate in 1930. It also enabled all the offices of the Development Corporation previously dispersed around the town, to be housed under one roof.

116

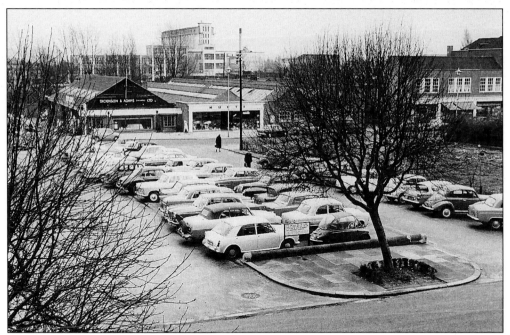

The small car park at the top of Stonehills in March 1964 which had to be removed to make way for road improvements and the sunken roundabout. In the background are Munt's famous cycle and pram shop and the town's earliest garage owned for many years by Jenner Parsons.

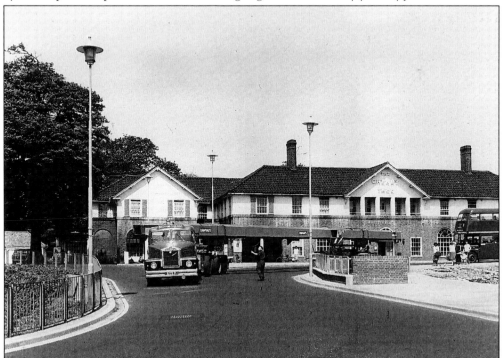

A lorry has difficulties negotiating the new sunken roundabout in May 1965. The girder it is transporting was on its way to Cambridge University and at 90ft in length was the longest Dawnays ever produced.

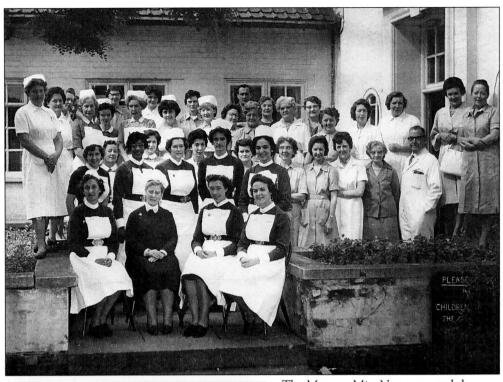

The Matron, Miss Newman, and the staff of Peartree Maternity Hospital in Peartree Lane in the early 1950s. This remained the town's maternity centre until the QEII hospital was built in 1963 when all services were transferred. The building was later taken over by the YMCA.

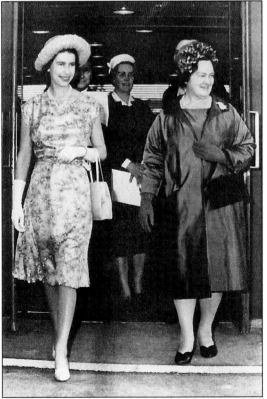

The official opening of the QEII hospital on 22 July 1963. The Queen is pictured with Mrs Ann Blofeld, Chairman Mid Herts Group Hospital Management Committee, with the hospital's Matron, Miss M E Stone in the background.

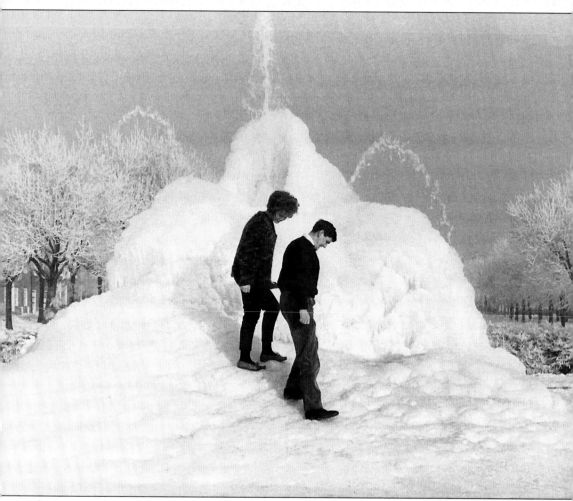

The fountain in Parkway February 1963. The severe winter of 1962/63 caused this iceberg to form on the Coronation fountain, the jets having been left on during the cold spell.

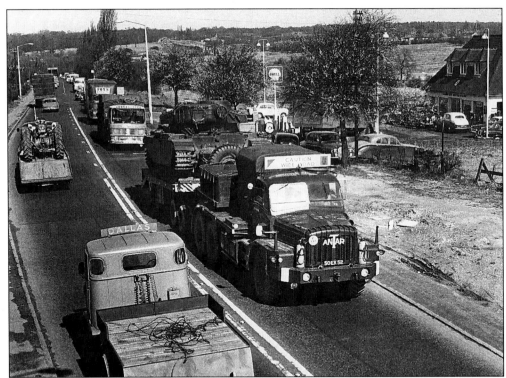

The A1 Great North Road at Stanborough in March 1967. It is hard to believe today, with the A1(M) motorway in use, that this was a major trunk road to the north.

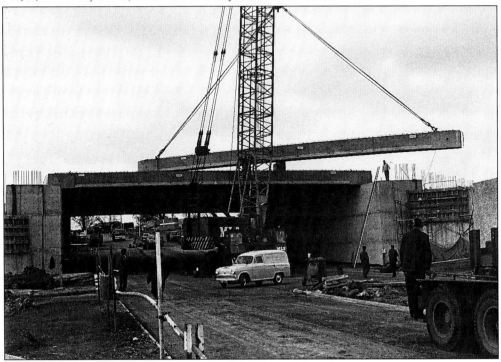

The A1(M) motorway bridge at Stanborough nearing completion in March 1967.

Twentieth Mile Bridge across the railway in October 1966 before the addition of another parallel bridge to form a dual carriageway.

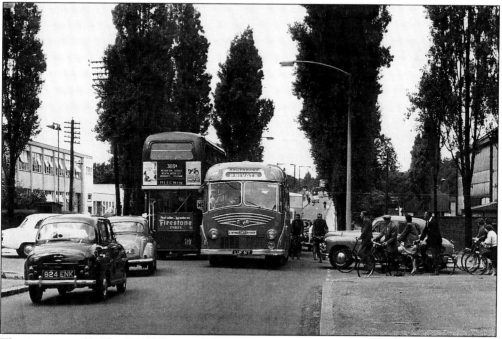

The junction of Bridge Road East with Bessemer Road and Broadwater Road at rush hour in September 1959. Shredded Wheat's factory is on the left with the old Hunters Bridge in the background and note all those cyclists. The junction has since been widened considerably to cope with the increased volumes of traffic.

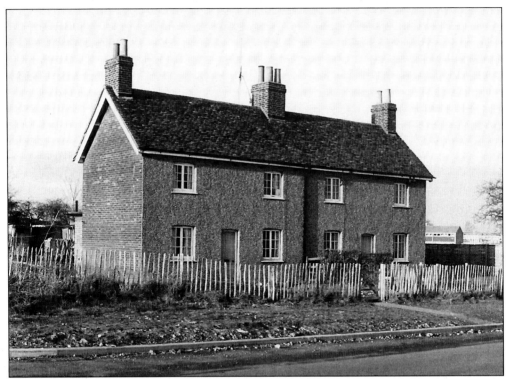

Grubs Barn cottages Herns Lane in November 1965. These two cottages were almost the only dwellings in the Panshanger area before the vast developments that have taken place since. Numbers 19-23 Herns Lane now stand on this site.

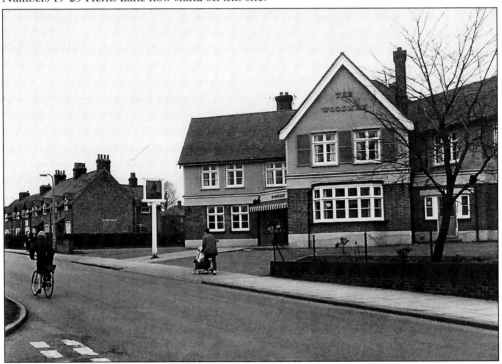

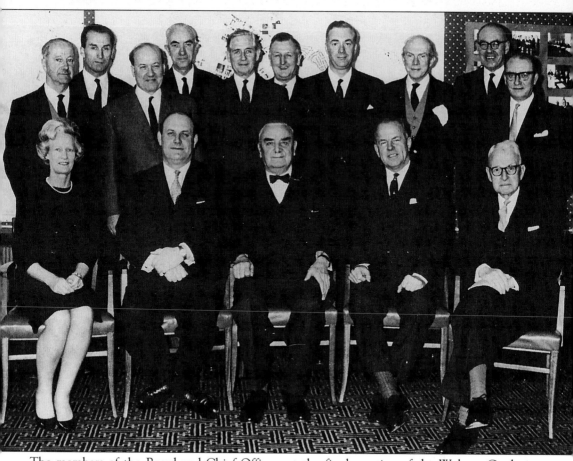

The members of the Board and Chief Officers at the final meeting of the Welwyn Garden City and Hatfield Development Corporation before the hand over to the Commission for New Towns on 1 April 1966. Mr C Gordon Maynard, Chairman, is seated in the centre.

Opposite: The Woodman public house in Cole Green Lane in 1968 before it was refurbished and renamed the Chieftain. The row of houses on the left, numbers 79-83 Cole Green Lane, were later demolished and replaced with council flats.

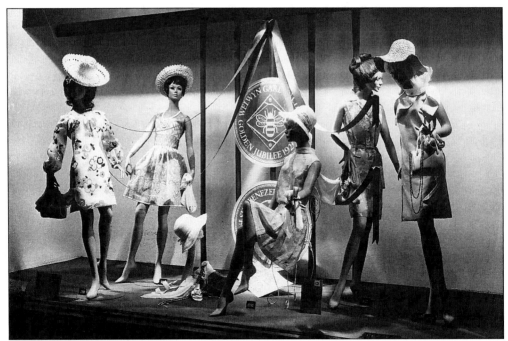

One of Welwyn Department Store's window displays for the town's golden jubilee celebrations in May 1970. The bee was chosen as the jubilee logo because it symbolised a community living and working together in a garden environment and featured on the Welwyn Garden City Urban District Council's coat of arms.

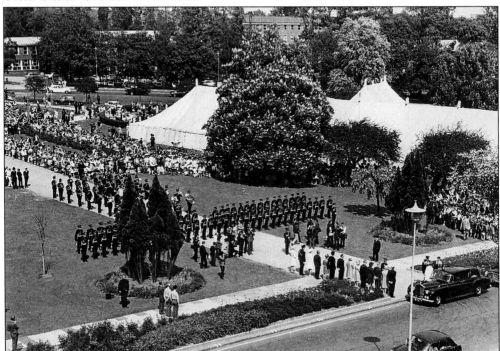

Queen Elizabeth, the Queen Mother, arriving to unveil the Louis de Soissons Memorial Garden on the Campus, 30 May 1970, the crowning event of the golden jubilee year.

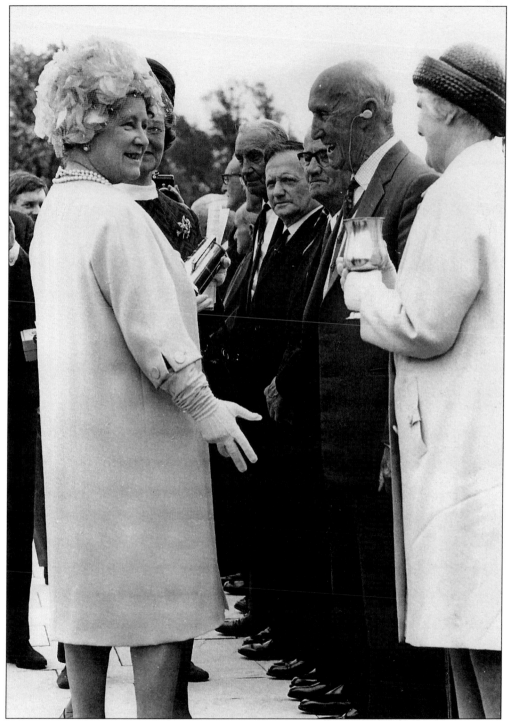

Mrs Molly Jennings and eighteen of the town's "pioneers" being presented to Queen Elizabeth, the Queen Mother, after the opening of the memorial garden. The men received tankards engraved "From the citizens of today to the pioneers of yesterday" and Mrs Jennings an engraved goblet.

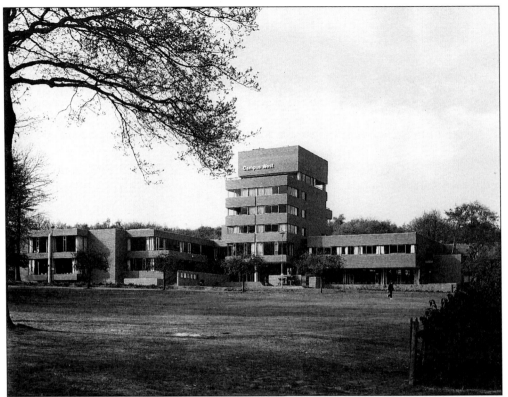

Campus West, the town's long awaited leisure centre which was opened by Dame Flora Robson on 8 December 1973. It houses a theatre, exhibition space, meeting rooms and one of Hertfordshire's largest public libraries. In the early years it suffered severe financial problems and in 1977 the tower block was taken over for use as council offices.

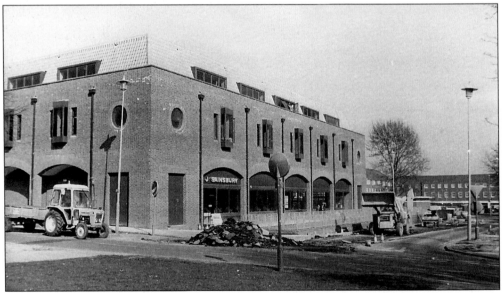

The first Sainsbury's supermarket on the corner of Parkway and Church Road nearing completion in March 1982. It was replaced by a new larger store in 2011

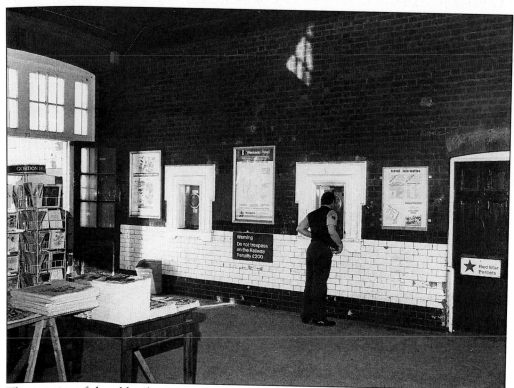

The interior of the old railway station booking hall in October 1987 before it was replaced in the Howard Centre development.

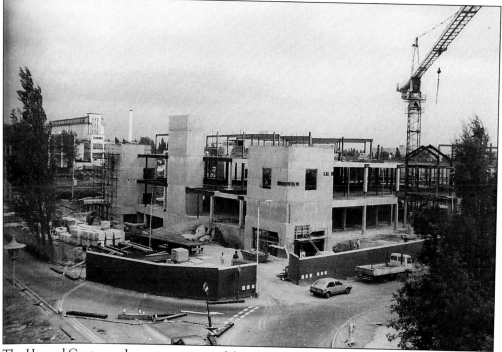

The Howard Centre under construction in May 1989.

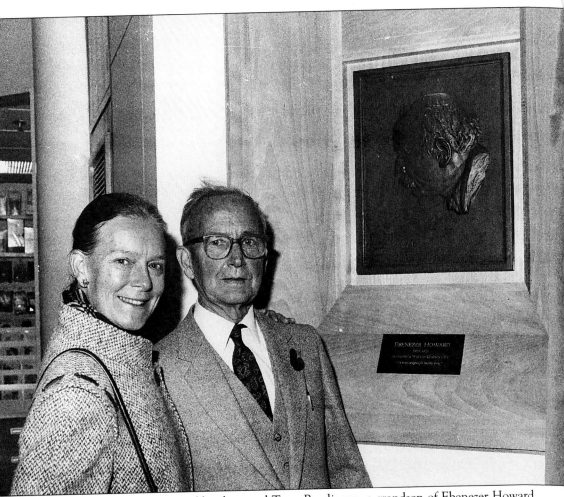

Ann Hackemar, a great granddaughter and Tony Rawlinson, a grandson of Ebenezer Howard, at the unveiling of the memorial in the Howard Centre on 7 November 1991.